Tom Thomson: Design for a Canadian Hero

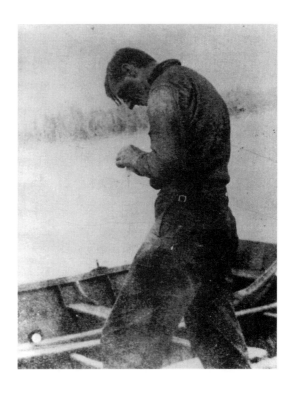

And I or you pocketless of a dime
may purchase the pick of the earth,
And to glance with an eye
or show a bean in its pod
confounds the learning of all times,
And there is no trade or
employment but the young man
following it may become a hero.

— Walt Whitman, *Leaves of Grass*, "Song of Myself"

Tom Thomson:
Design for a Canadian Hero

Joan Murray

DUNDURN PRESS
TORONTO · OXFORD

Design: Scott Reid
Printer: Transcontinental Printing Inc.
Front cover illustration: Autumn, Algonquin Park c. 1916. Private collection, Toronto
Back cover illustration: April in Algonquin Park, 1917. Tom Thomson Memorial Art Gallery, Owen Sound.
Frontispiece: Tom Thomson at Canoe Lake, Algonquin Park, c. 1915. Photo by Maud Varley.

Canadian Cataloguing in Publication Data

Murray, Joan
Tom Thomson: Design for a Canadian hero

ISBN 1-55002-315-2
I. Thomson, Tom, 1877–1917. 2. Painters — Canada — Biography. I. Title
ND249.T5M873 1998 759.11 C98-931571-1

1 2 3 4 5 02 01 00 99 98

The Canada Council | Le Conseil des Arts
FOR THE ARTS | DU CANADA
SINCE 1957 | DEPUIS 1957

We acknowledge the support of the **Canada Council for the Arts** for our publishing program. We also acknowledge the support of the **Ontario Arts Council** and the **Book Publishing Industry Development Program** of the **Department of Canadian Heritage**.

Printed and bound in Canada.

Printed on recycled paper.

Dundurn Press
8 Market Street
Suite 200
Toronto, Ontario, Canada
M5E 1M6

Dundurn Press
73 Lime Walk
Headington, Oxford,
England
OX3 7AD

Dundurn Press
2250 Military Road
Tonawanda NY
U.S.A 14150

Contents

Preface

Many biographers of Tom Thomson, and other writers who have taken him on as their subject, have viewed him with some justice as a woodsman, and thus the legend of the woodsman-artist was established. It was a myth he helped perpetuate, and like all good lies it has a kernel of truth: he did work for short spells as a park warden and guide. Yet, when we consider his life and the overall pattern of his career, we realize that the Thomson legend is an imaginative fiction that he himself created to add colour to the phenomena of his paintings. He gave life to a personna that was the expression of a painfully held emotional reality to a boy who was raised on the Romantic poets and who loved the time he spent in nature. That Thomson's projection of these beliefs and his image as a woodsman-artist continue to have such a profound hold on the public's imagination suggests that Thomson, as a hero, satisfies a secret desire on the part of our national psyche. We want a Paul Bunyan of the painting world — but a Canadian, not an American model.

Tom Thomson: Design for a Canadian Hero

Thomson has several qualifications that help him fill the role of hero. Given to silence, he spoke little even to friends about what motivated his work, which leaves room for enthusiasts to conjecture. His lack of formal education is also a sympathetic feature of his life — it's proof that he was no effete snob but a "regular guy." The events of his life, particularly his time living and painting in Algonquin Park, add to his stature, and we also sympathize with the resourceful way he filled the gaps in his learning, craftily mining the ideas of others to create his own work. And, once he got started, he did things in a big way — a heroic way. This we admire in him.

If Thomson had tried to explain himself to us, he might have said he was a designer. That was his craft and, he might have said, his gift. Design played a remarkable role in his life — from the way he looked at nature to the quality that raised his paintings above mere records of nature. Design gave to his art its maverick quality, its inspired delinquency. Unlike his peers, he used it with a spirited twist. He painted Canada less as an earnest duty than as a way of flinging down a challenge. At an early moment in Canadian art, he dared to look monumentally bold. His canvases — with their bright, poster-like colours, flat composition, and stained-glass handling applied in fat lateral brushstrokes as strong as the rocks of the Canadian Shield — depicted Algonquin Park only as their point of departure. He was a revolutionary of style, an innovator, a revitalizer of art — his paintings opened up new vistas, and artists today are still developing what he began.

He was, if you like, a hero who lived by design, and, quite by accident, the pattern of his life and work have provided a template for Canadian art. Hence the title of this book.

When I wrote *Tom Thomson: The Last Spring* (1994), I thought it would be the last I would write on Thomson for a while. But a year after that book was published, I was approached with a request to write a biography of the artist. I found myself thinking about Thomson, and particularly the ideas that motivated his painting. In the end, I decided to go ahead with another book. As in my earlier book, I was as concerned with trying to piece things together, to find out how they fit, as I was with making judgements. Thomson's work continues to move me deeply, but I see it as an expression of a variety of experiences in his life — experiences that stimulated the artist and therefore merit consideration. In the writing of this book, I am grateful to members of the Thomson family, among them Katherine (Kay) Fiske Morrison, as well as Helen and David Young, who kindly offered suggestions, and to Eric J. Klinkhoff of Galerie Walter Klinkhoff Inc. in Montreal, and several private individuals, for their financial assistance.

Joan Murray

I

Ties that Bind

Tom Thomson's family set a pattern of unselfishness, and he would always be drawn to people like them. He was himself good-hearted. "Anything he had was always shared with his playmates, and if there were only two, himself and a friend, his friend always got the larger share," wrote one childhood friend, Alan H. Ross. Thomson learned these generous ways from his mother, who was charitable to the poor and needy. It was Margaret Matheson Thomson who organized the legendary hospitality of their home. "It snowed of meat and drink in that house," wrote Ross, echoing Chaucer. Thomson's mother loved to read and, even with nine children, she found time to delve into archaeology, geology, astronomy, poetry, and fiction, as well as her daily *Globe*. She gave her son her remarkable memory, and when we see her in a photograph, we sense that it was also from her that he got his droll sense of humour: she has the same puckish expression on her face. From John Thomson, his handsome father, he got his strong features, his high

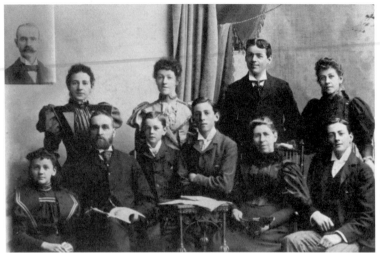

The Thomson family, c. 1898.
Front row: Margaret, John (father), Fraser, Ralph, Margaret (mother), Tom.
Back row: George (above, his photograph was inset as he was in Seattle and not present for the session), Elizabeth, Louisa, Henry, Minnie.
Photograph by E. Tucker, Owen Sound, courtesy of Joan Murray Tom Thomson Papers.

Notice the way John holds an open book in his hands, with a finger marking the spot where he had stopped reading to wait for the photographer to snap the picture; he, and all the Thomson family, enjoyed reading. Of the two, Margaret had the energy. Her humorous, slightly puckish expression recalls that of Tom.

principles and careful ways, his great powers of concentration (when he wanted to use them), and a fine tenor voice.

Gathering the family around them, his parents enjoyed musical evenings. The children — George, Elizabeth, Henry, Louise, Minnie, Thomas, Ralph, Margaret, and Fraser (one more child, James Brodie, had died in childhood) — were all musicians in one way or another, and all devoted to music. For his part, Tom Thomson took up the cornet, the violin, and the mandolin. They were a family with a passionate urge for creative expression; they were upwardly mobile and they were cultured. Their uncle had been good at drawing and their father sketched; as a result, almost all the family drew or painted. They also loved to study and to read good literature. John Thomson had always loved reading, and would read all night when the mood was on him. A graduate of the first-class Whitby

Grammar School in Whitby Township, where he was born in 1840, he helped his children with grammar and mathematics. At night the family sat down to read aloud family favourites: the novels of Sir Walter Scott, Dickens, George Eliot, the poetry of Byron. They wove and rewove the tale of the family's move to Canada.

The story of the family's immigration to this country is an eventful one. It began in 1806 in St. Fergus in Aberdeenshire in northeast Scotland, where John Thomson's father, Thomas Thomson (called "Tam"), was born, and where he met Elizabeth Brodie from nearby Peterhead. During the 1830s a wave of Scots sought their future in the farmlands and lumber yards of Canada, and especially Ontario. In 1833, Tam sailed for Canada; Betty followed in 1835, travelling with her uncle George and his family, and with a close girlfriend. Tam and Betty married in 1839, and settled first near the town of Whitby, east of Toronto, then on

10

a farm in the Township of Pickering, near the smaller town of Claremont, where he took up fifty acres to which he added two more properties, making in total a farm of a hundred and fifty acres. Good-natured and quiet, Betty Brodie Thomson was long remembered for her precise ways, and for her splendid flower garden; Tam was known as a genial romancer and teller of yarns, and a sympathetic friend. He and the Brodie family (which had settled close by at Craigieburn Farm in Whitchurch Township north of Toronto) and especially George's son, James — Betty's first cousin, remained close throughout their lives. When Tam died, James was one of the executors of his will. The other was Tam's only child, his son John.

John received his early education at the common school in Claremont, then he attended Whitby Grammar School. After graduation, he returned to his father's farm. True to his roots, when John chose a wife he selected Margaret Matheson, who was of Scottish descent. Her family had come from the Isle of Skye to Prince Edward Island, then moved to Morriston, near Guelph, Ontario, and when her mother died her father moved to Glenarm, Ontario to be near relatives. From there, his daughter moved to Claremont, where she got a job as a servant on Tam's farm — and met John Thomson.

Like her husband, and later her children, she had simple, natural manners. She was always hard-working. It was she, aided by a photographic memory, who had the

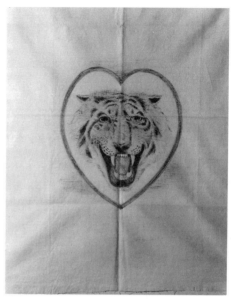

Tiger Pillowcase, c. 1908?
Ink on linen, location unknown. Photograph courtesy of Joan Murray Tom Thomson Papers.

Thomson made this drawing on a pillowcase as a present for his mother.

business ability in the family. There was no pretension about her. Her son Tom had the same quality of utter simplicity. Ross, Tom's boyhood friend, recalled that Tom "was always as plain and easy as an old shoe. There was never the slightest pretence, affectation or self-consciousness about him." He was also unusually reserved and quiet, though not with his own folk. Within the family circle, he was a charmer: he sought to entertain others, especially Minnie, the sister closest to him in age. When he sketched ships and boisterous waves with his finger on the steam or frost covered kitchen window, she noticed. He sometimes drew caricatures of people they

11

knew, and kept them all laughing and guessing who they were. "When he got an extra good caricature, a whimsical grin came over his face," Minnie lovingly wrote. That was about 1905, as we know from the sketchbook that contained the drawings. In 1907, home for a visit after her marriage, she recalled him sitting in a big armchair with his sketchbook on his knee, drawing prowling and ferocious-looking tigers ready to spring from a tangle of jungle grass, while two of their sister Elizabeth's children, thrilled and spellbound, perched on the arms of his chair, and another peered over his shoulder. The urge to amuse others was deeply engrained in his character.

In psychological terms, he was what is called a "pleaser," a man who suppresses his personality to satisfy the needs of others. Some say this type of personality prefers middle-of-the-road jobs because it seeks feedback from others and a boss's seal of approval. "When things go wrong, emotions build up inside," writes the clinical psychologist Barbara Killinger. "Instead of verbalizing their hurt and confusion, pleasers absorb their anger and feel guilty. Since guilt is self-anger, it only adds to their distress. They become depressed, moody…. They may walk away to avoid their own anger…. Many carry grudges for long periods of time, and unresolved anger arises each time a related issue surfaces….. Like a slow volcanic eruption, passive-aggressive anger, both conscious and unconscious, bubbles away."

Thomson was everybody's friend. In 1914, Arthur Lismer wrote that he found Tom a splendid companion, totally capable, a sincere and able artist, unassuming. Praise from others could be listed. Franklin Carmichael and friends in the engraving trade always spoke of Tom's good nature. "He was one of the two most generous and open hearted men, it has ever been my pleasure to know," wrote Ross (the other such man was Tom's brother, Ralph). A.Y. Jackson always said that Tom wanted to do all the work — he meant canoeing, carrying the pack, or cooking when they camped. Yet there was anger hidden inside, anger that could erupt. "Thomson had strange antipathies and the few people he did dislike he hated most cordially," wrote Ross. "He was not at all diplomatic in concealing it either." And since he was sensitive — some people, like Jackson, would even say overly so — he often got a chance to have his feelings hurt.

Other clues to his personality can be found in the accounts of his brothers or friends such as Lawren Harris. They vividly recalled Thomson's fits of despondency. When he was discouraged, Tom would sit looking at a work of design or a painting on his easel and try to destroy it, smearing it with ash, or breaking wooden matches to throw them at the wet paint surface — a repetitive action typical of inward rage. Other signs of his repressed anger were his moods — often up or down. To get away from his own or others' anger, he would walk away. Harris later recalled that during the winter at his shack in Toronto

Thomson would exercise at night by putting on snowshoes to tramp the length of the Rosedale ravine and out into the country. We conjecture that through the passage of time, and his bodily movement, he set behind him a difficult painting. His reaction to emotional entanglement was flight. In 1904 in Seattle, where he had gone to attend business college, he fell in love, but when difficulties arose, he left town, never to speak to the young woman again.

Killinger observes that pleasers can carry grudges for long periods of time, and that unresolved anger arises each time a related issue surfaces. In the murky circumstances surrounding his death in 1917, one fact is clear: he was again coming close to marriage.

Inside himself, like any pleaser, Thomson may have felt that he was a failure. "He particularly resented anything like public ridicule," Ross wrote. Perhaps

being treated as ridiculous struck too close to his fears. "I'll show them" was his reaction. Part of his fear of being held up to derision was grounded in a dislike of authority: while in his teens, he stood up to J.B. Fraser (1864–1916), the powerful minister of Leith Church. To this antipathy he added something more serious when he was finally accepted as an artist: fear of discovery. He felt that he was a phony and that his work would be revealed for what it was. "They call this art," he sneered to a friend, tossing aside one of his panel paintings.

Thomson's guilt would have stemmed from several factors. Probably most important was his reaction to his uncompromising father. "With John Thomson, right was right, and wrong was wrong," Tom's sister Minnie wrote. John was morally rigid, and a disciplinarian. Tom was the sixth child, and a bit of a

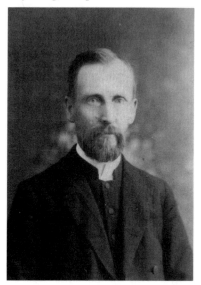

Reverend J.B. Fraser (1864–1916). Photograph courtesy of Joan Murray Tom Thomson Papers.

Minnie Thomson. Photograph courtesy of Joan Murray Tom Thomson Papers.

hell raiser — or at least he liked to have fun. Probably he felt an unpleasant suspicion that he had done something wrong. He may have felt regret that he hadn't achieved what he should. Within his achievement-oriented family, he likely was criticized for not sticking to what he started. Perhaps his father said he didn't have "grit." In a letter to his father in the spring of 1917, the last letter he ever wrote, he said, "I'll stick to painting as long as I can." The words are suggestive: they sound as though the father believed his son could not stick to anything much. Thomson probably felt a discrepancy between what he was and what he would have liked to be. He would have blamed himself for his lack of success.

All this came later, of course. Yet, even growing up in such an ambitious family, he would have harboured secret dreams. His upbringing trained him to hope to achieve. It was accepted among the family — and by friends such as Ross — that he was the one with the artistic temperament, but he was still expected to do his part, to contribute to life in Canada. His mother and father had imbued in him the values of hard work and success. For them, one aspect of success, a very Scottish one, was money.

The economist, John Kenneth Galbraith, himself a Scot, in his book on *The Scotch in Canada*, wrote that money for a Scot is pure love. "The Scotch wanted it for its own sake." He continued, "Two techniques for accumulating assets have always been in some measure in competition. One is to earn money; the other is to avoid spending it." John Thomson would always be lackadaisical about the accumulation of assets, but he would have given his full approval to the latter method. For him, as for other fathers among his acquaintances, his sons were his investments. They were to give him "his money's worth," he thought; so, after they attended primary school in Leith, he required them to work on the farm until they were twenty-one. His daughters and some of the younger boys, however, made it to high school, and in time, the men got business school training. Perhaps John Thomson even told his own father how he felt — that his boys owed him a living. This, and an impractical side to his nature, may have been the reason for Tam's curious will. He left half his estate (about $20,000) to his son John, and the other $20,000 to be divided among his grandchildren, "payable to each of them on attainment of majority." Tom Thomson had to be of age before he got his freedom, but at least, with the help of his grandparents (for the money seems to have originated with his grandmother), he got it.

On the farm, his life passed peacefully. "The Thomsons were no different from anyone else, everyone was poor," a neighbour described the family's life in Leith. John Thomson was not particularly hard-working. Neighbouring farmers never took his farming seriously. He sometimes would plant a field of turnips and never get around to harvesting it, recalled an acquaintance. If

the weather was good, he might go fishing instead. He and his son Tom were ardent fishermen and huntsmen, and thought nothing of walking miles for a day's sport.

He also loved his half-acre of garden, and on it lavished attention. To enrich the soil, he brought cartloads of silt from a nearby swamp; to protect it, he surrounded it with a white picket fence. Inside was a little of everything, mostly a rich selection of flowers, but also herbs, grapevines, and a few peach trees. That he loved his garden best, and did not do much work in the fields, suggests that John Thomson didn't mind being different from the farmers around him. Clearly, he regarded his farm less as a money-making proposition than as a healthy place to raise a large family. As soon as his boys moved away he left Leith for a small farm close to Owen Sound, which he soon sold to move into town.

The flowers John planted and loved are a key to his character. "He painted a picture within that picket fence," said an acquaintance. All his life he had been intense though absent-minded. One time, an acquaintance recalled, after the family had moved to the farm near Owen Sound, Margaret handed John a pan of potato peelings to take out and give to the hens. A friend met him half an hour later, the pan still under his arm, in downtown Owen Sound. Clearly, he was forgetful.

From his father, Tom inherited several traits. He, too, would be abstracted, lost in thought. He wanted to be independent, and to see the world. His father had left the family turf at Claremont for Leith; Tom wanted to be a sailor or enlist in the Boer War — but he was not allowed to go, not only because he was needed on the farm but because he'd been sick as a child. One sister spoke of weak lungs, and another of rheumatoid arthritis. As a result of his illness, his parents kept him home. Since part of the treatment, along with appropriate rest, is exercise, he was encouraged to wander freely through the countryside, and enjoy long, uninterrupted hours of fishing and hunting. In this way, he developed his love of the outdoors. It was the only unusual aspect of an uneventful childhood, yet it seems to have set him apart from family and friends; it may have been enough — along with one other factor — to make him an artist.

The mysterious factor was his relative, Dr. William Brodie, the son of his grandfather's old friend James, and thus his grandmother's first cousin (though the family always called him "uncle"). Born in 1831, he was nine years older than Thomson's father. As Thomson grew up in Owen Sound, he heard about Brodie and his work as a naturalist. He was one of the famous men of the day, known not only for his work as an entomologist, ornithologist, and botanist, but also for his strong interest in vertebrate groups and mollusks. One phenomenon that particularly interested him was tree galls, the abnormal outgrowths

15

produced by an insect, fungus, or bacterium on a plant, especially an oak. He was a man who undertook much — he discovered some twenty new insect species and many new forms of previously described species. In 1877 he helped found the Toronto Entomological Society (which changed its name to the Natural History Society of Toronto in 1878); from 1903 until his death in 1909 he was director of the Biological Department of the Ontario Provincial Museum (later the Royal Ontario Museum) in Toronto. There, in addition to administrative duties, he retained his enthusiasm for scientific investigation and philosophy. He always believed, as did John Thomson, in beauty as a distinct quality.

Notes made at a meeting of the Brodie Club more than fifteen years after Brodie's death offer us a sense of his qualities. One incident in particular captures his personality: a colleague, visiting his office at the museum to talk with him, heard a rustling sound coming from his wastepaper basket. "There's a mouse with nowhere to go," said Brodie. "I feed it there." At his home on Parliament Street in Toronto, he entertained artists, scientists, politicians, and university students. "He especially delighted to have young people around him," perhaps because of the early death of his son Willie, a promising naturalist, or perhaps simply because he was a gentle, generous, outgoing man.

He inspired young people, and aroused or stimulated their interest, particularly in natural history.

He encouraged, among others, the painter and naturalist Ernest Thompson Seton, and Charles Trick Currelly, later the first director of the Royal Ontario Museum. Currelly recalled him as a person who devoted much of his time to boys.

His open mind and the way he inspired young people were remembered by his colleagues even many years later. "Brodie had not only the eye of the scientist and of the artist but his philosophical mind sought an explanation of what he saw," read the minutes of the meeting held in his memory. Yet his formal schooling had lasted only two weeks, he said; for the rest, everything he knew came from his mother, his reading, and a few months' study with a doctor. This brief apprenticeship enabled him to set up practice as a dentist in Toronto in about 1857 or 1858 (hence the prefix "Doctor" by which people commonly addressed him).

Brodie was famous for his hikes. They started from his house at seven in the morning and went on for hours. He was remarkable for his acute observation. Among his interests was philosophy: he liked to debate on the eternal verities. In this he was similar to other naturalists of the nineteenth century, who saw in nature proof of divine activity, though by this they might not mean "God." The historian Carl Berger has written perceptively of the way this belief equated science with worship, and reverence for nature coloured perceptions of its laws and facts. In consequence, the

study of natural history was invested with a certain mystery, even holiness. Brodie, who was such a close observer of the natural world, would surely have seen in nature its great design.

It is clear from the minutes that Brodie was loved by his colleagues, and that he in turn loved them and encouraged them in various lines of research. Also noted was his remarkable accuracy in identifying new species. Unfortunately, with respect to publishing, he was a procrastinator — perhaps because he was embarrassed by his lack of education, or because he never felt he had all the information he wanted. Yet he kept voluminous notes and journal records of his observations, and he encouraged others to do likewise. In 1881 he advised Seton not to fail to keep a journal of his western travels. "You will be sorry if you omit this," he said, and "you will value it more each year." Seton's "Journals of his Travels and Doings" (now in the library of the American Museum of Natural History in New York) covered the next sixty years of his life. No doubt Brodie gave Tom Thomson similar advice — keep a full and accurate journal.

Thomson also learned from Brodie how to collect specimens; as a young man, he accompanied his relative on collecting trips. He also gathered specimens for a high school teacher, David White, in Toronto's High Park and Scarborough Bluffs, two of Brodie's favourite collecting spots.

There are parallels between the lives of Thomson

Photograph of Scarborough Bluffs taken by Tom Thomson. Photograph courtesy of Joan Murray Tom Thomson Papers.

and Brodie. Each spent a long time choosing a career — Brodie was first a schoolteacher, then a dentist, then a biologist. Each lacked a formal education. Most importantly, each man had the naturalist's way of seeing. It involves observing keenly and with enthusiasm, and feeling a sacredness in the life of creatures. Maud Varley, the wife of Frederick H. Varley, recalled how, on a visit to Algonquin Park, Thomson took her by canoe to see beaver dams. "He was quite shy and very gentle," she wrote. "He got great satisfaction from a baby deer, probably motherless, that came each night and lay down just outside his tent, just to be near somebody."

The eye of a naturalist is central to Thomson's later painting. It accounts for the way he saw the land — so

Owen Staples (1866–1949)
The Brodie Memorial Portrait, 1914
Oil on canvas, 76.2 x 91.4 cm
Ornithology department, Royal Ontario Museum, Toronto.
Photograph courtesy of the Royal Ontario Museum, Toronto.

Tom's cousin, Dr. William Brodie, one of Canada's great biologists and botanists, introduced him to the study of nature. Although he died in 1909, he was so well-loved by his students and friends that they commissioned this portrait of him five years later.

accurately, almost as though it were a contour map laid before him. From travelling over Algonquin Park, he knew what was behind and beyond what he painted. He conveyed this knowledge in the small sketches he liked to call his "boards," because they were painted on pieces of wood.

Thomson's tramps, his joyful recognition of old plant friends, recall earlier excursions by Brodie. A.Y. Jackson remembered his early conversations with Thomson as centering on wildlife. Another friend, Arthur Lismer, observed how animated he became in the bush. "He saw a thousand things — animals and birds, and signs along the trail that others missed."

Brodie was the person who sharpened Thomson's love of nature into knowledge. Yet without an education, at least at the university level, Thomson's great talent for such studies meant nothing. The

thought rankled. He was bitterly disappointed over the lack of opportunity, his sister Minnie later recalled. The denial of his capacities contributed to his anger.

Family friends never knew the anger that was banked in the gentle young man with the thin Indian-like face, long nose, and straight black hair falling over his forehead. They saw only his kindness, his generous nature, his handsome appearance. They thought he was reconciled to life's circumstances. Minnie said he liked a short gem of Henry Van Dyke's, a saying from the popular literature of the day, and copied it often. It expressed his creed and described his character, she said. The short passage is called "The Footpath to Peace," and describes the guideposts by which a person should live. It begins, "... be glad of life because it gives you the chance to love, and to work and to play, and to look up at the stars." It ends with an exhortation

18

"to spend as much time as possible, with body and with spirit in God's out-of-doors."

The last, at least, was possible. Thomson lived an outdoors life, in his heart and body, whenever he could. Through his later paintings he would increase our store of knowledge about the wilderness.

Yet this is only part of the story. His angry side expressed itself in other ways, possibly even when, as a man, he reached for paint to do his best work.

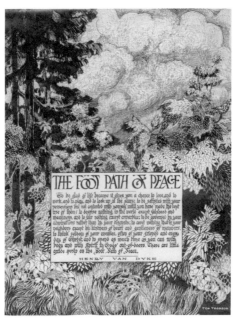

Tom Thomson
The Foot Path of Peace, 1914–1915
Illustration from a quotation by Henry Van Dyke
Pen on vellum, (21.75 x 28.25 cm)
Private collection, Toronto.
Photograph courtesy of Joan Murray Tom Thomson Papers.

Thomson gave this sketch to his parents as a Christmas present.

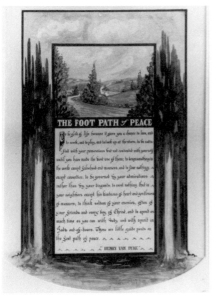

Tom Thomson
The Foot Path of Peace, c. 1905
Illustration from a quotation by Henry Van Dyke.
Ink, wash, and watercolour on paper, 38.1 x 27.9 cm
Photograph courtesy of Joan Murray Tom Thomson Papers.

A teacher in Ottawa who boarded in the same home as Thomson, Mary Elizabeth McIntyre, rescued this penmanship sample from the garbage: Thomson wanted to throw it out because it had an error.

Tom Thomson, c. 1900.
Photograph by E. Tucker, Owen Sound, Ontario.
Photograph courtesy of Joan Murray Tom Thomson Papers.

Tom was handsome. Friends remember that a lock of hair fell into his face. To get it out of the way, he tossed his head back, a characteristic gesture.

19

2

Footloose and Fancy Free

Owen Sound in the 1890s was a bustling town with what looked like a prosperous, unlimited future. It was the safest harbour on the Upper Great Lakes, providing an ideal point of departure for ships on their way to Canada's east. All it needed for success, it seemed, was a rail connection, and in 1883, the break came: the Canadian Pacific Railway selected the town as its eastern terminus. The choice was a bonanza for the town's growth. In 1871 it had a population of 864; by 1891 it had grown to 7,497. By 1897 the CPR owned town property worth over three million dollars, including freight sheds and a new grain elevator. Kennedy's Foundry, owned by close family friends, and where Thomson was bound as an indentured apprentice in 1899, provided the materials for machines, and trained machinists to build them. Business was good.

Today, the term "indentured apprentice" has an archaic sound. An indenture was a written contract that bound an apprentice to a master; such elegant old documents

are sometimes framed and used as decor. Kennedy & Sons was a good business to which to be apprenticed — it was thriving. Thomson's boyhood friend, Ross, was apprenticed there in 1894; Thomson followed him five years later. He only lasted eight months, since he and the foreman, a gentle spirit, "never got along" (the description is Ross's). The disagreement was probably not so much the foreman's fault as it was Thomson's. As we know, he had an independent streak, and he also suffered from another family habit — tardiness. (All the Thomsons, Ross said, lacked the sense of punctuality.) The time he spent at the job suggests that what was on his mind was to work till he got some cash, then go home for the summer to loaf and fish. Thomson later told Ross that he bitterly regretted leaving the job. It was probably the steady wage that he regretted losing, but in time he was to find employment in another growing industry: publishing and printing. For the moment he went home, then travelled to Chatham, Ontario, as his brothers had before him, to attend the Canada Business College.

Because of his childhood illness, and the way his father had kept him on the farm, Thomson only had the basics of an education. Primary school taught reading, writing, and arithmatic, but not much else. Even if he had gone to high school, it would not have provided the training necessary for business. But his family wanted him to have a career, and he needed to fill his gaps. Business college, said newspaper articles of the time,

provided a more formal, better organized, and directed system of commercial courses than the public school system or Mechanic's Institutes. At the Chatham School, courses included bookkeeping, banking, arithmetic, spelling, and penmanship (this meant a fine Spencerian hand). The latter was the speciality of the principal, D. McLachlan, who had for years, said the honour roll published by the college in 1904, carried off all the first prizes in penmanship at the leading exhibitions in Toronto, Hamilton, London, and Ottawa. Penmanship became an area in which Thomson excelled; he is described in the honour roll as a good "penman." We can see his art in the lettering samples by him that have survived. They are well designed, though different from the florid style advocated by the school. Still, at the time he was a student, he would have been fascinated by the swirly scrolls of the illustrated pictures published by the school. In other subjects, he was doubtless not very good — we know that his banking records always left much to be desired. Yet Chatham (a town of 9,000) and the school probably meant a lot to him. It would have been a second effort at independence from his family, though, as with Kennedy's Foundry, he only stayed eight months. Then it was time to go home again to summer with his family in Owen Sound, where they had moved by then. Ross reported that when he was in Chatham, Tom spent most of his money on movies and dances and having a good time. "He seemed to me at the time to be drifting."

Hotel Diller, Seattle, c. 1903.
1220 First Avenue, southeast corner of University.
Photograph courtesy of the Museum of History and Industry, Seattle.

When Thomson first arrived in Seattle, he worked as a lift boy at the Hotel Diller.

The Chapin Building, southeast corner of Second Avenue and Pike Street, Seattle, between 1901 and 1906. Photograph courtesy of Museum of History and Industry, Seattle.

The second window on the right on the second floor reads "Acme Business College."

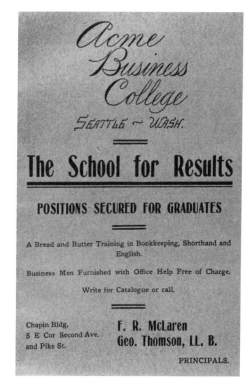

Advertisement for Acme Business College, Seattle City Directory, 1903, p. 31.
Photograph courtesy of Museum of History and Industry, Seattle.

Thomson's spell of unfocused wandering continued for the next two years. After going home, he went west to Winnipeg to work at the harvest, then followed the trail of his eldest brother George to Seattle. There he settled in 1901, first working as a lift boy at the Hotel Diller in the international section of town, then once again attending business college. George and F.R. McLaren, both from the Chatham School, were running the school in Seattle, the Acme, which they had started, amalgamating it in 1894–95 with an earlier school. Later, George, who served as the school's accountant and treasurer, said it had been ranked

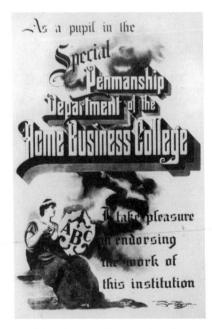

Endorsement of the Special Penmanship Department of the Acme Business College, c. 1902, location unknown. Photograph courtesy of Joan Murray Tom Thomson Papers.

eleventh in the United States: photographs do show it as a fair-sized establishment. Though the school moved frequently, it was always in the heart of Seattle's business section: on Second Avenue or Third and Pike.

It was at this time that the first examples of Thomson's art were made. A testimonial that he prepared for the school reads: "As a pupil in the Special Penmanship Department of the Acme Business College, I take pleasure in endorsing the work of this institution." On the left is a fashionably plump allegorical figure, possibly Fortuna, who holds a shield inscribed with the letters ABC. He also designed a business card for himself, and the advertisement for the school which appeared in 1903 in a special Christmas issue of *The Seattle Republican* (in which he signed his name at the bottom with the elongated "s" characteristic of his signature until 1911). The ad is elaborate, but has its own logic: in the background is the base of a large, shaded triangle with its apex pointing downward into, and hidden by, the bend in a ribbon-like banner bearing the names of McLaren and George Thomson with their photographs inset above. At the bottom of the ad are leafy branches tied with a bow that extend on either side, and in the centre, touching the banner, is a springy spray, half space-filling design, half flowers. The work is that of a man showing off what he has to offer with exuberance. He was proud of his talent.

From the first, the Acme had advertised that it

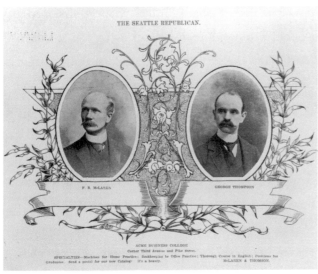

Advertisement for Acme Business College, 1903.
The Seattle Republican, Greater Seattle edition X, no. 28, December 25, 1903.
Photograph courtesy of Joan Murray Tom Thomson Papers.

Thomson was so talented that the principals at his college in Seattle, one of whom was his brother George, quickly put him to work preparing advertisements for the school.

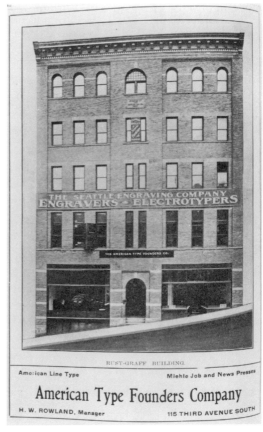

Seattle Engraving Company, Rust-Graff Building, Seattle, 1905.
Polk's Seattle Directory Co.'s 1905, p. 42.
Photograph courtesy of Joan Murray Tom Thomson Papers.

Tom Thomson worked for the Seattle Engraving Company, which advertised that it had on staff fifteen engravers and five artists. In 1905, the firm had its offices in the Rust-Graff building at 115 Third Avenue South. The building is still standing.

Maring & Blake advertisement, 1903.
Seattle City Directory 1903, p. 806.
Photograph courtesy of Museum of History and Industry, Seattle

helped obtain positions for graduates. With his own ability and the help of his brother George and, no doubt, other friends who had come from Canada, all trying to make their mark, Thomson got his first job. The company was run by C.C. Maring, one of the graduates of the Chatham School, and the job was in engraving. He worked briefly for Maring & Ladd (which changed to Maring & Blake soon after he arrived due to a change in staff), then was hired by their strongest competitor, the Seattle Engraving Company, at an increase of ten dollars a week.

The engraving company of the day should be called a photo-engraving house since the kind of work it did involved the use of the photo-mechanical printing plate process. It was an early kind of advertising agency; its chief business was preparing illustrations for a variety of publications, from city directories to magazines and newspapers. Maring & Ladd was the first such firm west of Chicago and had a monopoly on those who did not wish to take their business east. It specialized in colour illustration — a first for the area. Maring was the artist member of the firm (today he would be called the art director) and Ladd was the photo-engraver. But apparently Ladd was more interested in movie projection, as he was soon replaced by Edgar L. Blake, another artist from Canada. If we look at an example of C.C. Maring's work from 1903 (during the time of Thomson's period of employment) — a flowery endorsement of D. McLachlan, the

principal of the Canada Business College, designed for a booklet to promote the school — we realize that Maring was the sort of person who believed in banners of ribbon in the sky, lettering festooned with ivy, and emphasis on starting and closing letters. (In the case of the Canadian school, with animals such as elk and beaver.) In other words, he was of the florid school of design. Other work done by his firm at the same time, however, such as an advertisement for the Vulcan Iron Works, shows us that the company was also happy to convey, upon request, a sensitive appreciation of the finer points of Seattle's landscape. The illustration for Vulcan shows the port and distant mountains, while hinting at a sunrise.

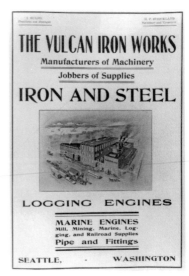

Maring & Blake advertisement, The Vulcan Iron Works (central illustration signed by Maring & Blake, Eng[ravers]), *The Argus*, December 19, 1903, p. 65. Photograph courtesy of Museum of History and Industry, Seattle.

26

Clearly, the firm was up-to-date in applying what were then the contemporary principles of design and, like others of the period, was influenced by what museums call the Aesthetic Movement of the 1870s and 1880s. The movement had begun in England and then spread to the Continent and North America; through it, design had become an expression of national identity, just as the Gothic style might indicate England's medieval world. Its most pervasive influence was Japan, but other cultures — most notably the Islamic world — were drawn upon for their contributions to design. Through such borrowings, the West asserted its hegemony in design as it had done more forcefully in the realm of politics. Such work was a form of imperialism, albeit in art, and for designers, plundering other cultures had a liberating effect — it made them feel free to change gracefully from one way of illustrating to another.

It was not long before Thomson's work was equal to that of the more experienced artists, his brother, Fraser, wrote later. Tom was successful in the job: no customer ever refused to accept his work. His brother Henry recalled that he often worked all night, trying first one idea, then another. The ones that did not meet with his approval he would either throw in the wastebasket, burn, or smear with cigar ash or the ends of burned matches, a foreshadowing of his practice later as a painter. Again we hear of trouble with his boss, and the explanation sounds familiar too: he was

Business card, Seattle, c. 1903, location unknown. Photograph courtesy of Joan Murray Tom Thomson Papers.

Tom attended Acme Business College in Seattle to study commercial art: his design for his business card indicates his study of advertisements of the day.

designing "to suit his own ideas," said Fraser Thomson.

We also hear of one habit that would prove to be important to him: it is a common way of working for artists even today. He studied newspapers, magazines, and books, chose the best illustrations and advertisements he could find, and reworked them. His brother Ralph called it a form of play, and described how Tom played a game with himself over how he could improve on the originals. He changed the entire design to suit his own ideas, and then compared the respective merits of the two ideas. For the design of his business card, for instance, he may have drawn upon an advertisement for Maring & Ladd.

The way he transformed a source reveals his independent mind at work again, the mind of a person who believed that art was a vast bank of tradition that he could draw upon at will. Yet his grasping at compositions already used in his field was the resource

of an artist who sorely felt his lack of training. There was something desperate in the way he educated himself. What he lacked forced him to become somebody else, someone clever, who created work out of messages from the past, from other artists. In a way, he recreated himself with each job. That course of action makes him an ideal prototype for some of today's artists, who feel themselves to be citizens of an apocalyptic new world of art. As for the sources themselves, they are hard to recognize because they may be far removed from their places of origin, but

they underlie his work like stones in the running water of a stream.

Among the works dated to these years are two sketches: one of a woman with piled-up hair and another, a watercolour, of a woman looking in a mirror. The first has the rapid penwork Thomson had learned in business college and shows his deft handling. It could be a portrait (the woman with whom he was involved in Seattle thought it looked like her), but it is more likely a characteristic type drawn from magazines known as "The Gibson Girl" — a swan-necked beauty with a tiny head, pert nose, and rosebud lips. He painted the watercolour with a spoof in mind, we feel, since he probably found women's narcissism comical. The woman's arm is well drawn, but the way a lock of hair falls over her face shows us that he intended it to be amusing. He meant to charm. The works prove that he was still, as an artist, an amateur. He had not yet "found his path" as some would say of those who later become great.

Perhaps his greatest achievement in Seattle was teaching himself the elements of design through studying the work of others. He must have found it similar to the way he read music — just glancing at a sheet of music revealed to him the intentions of the composer. Only an artist with a powerful memory would find the method helpful, but Thomson had his mother's "total recall." John le Carré, in *A Small Town in Germany* (1968), says about a diplomat who has proved

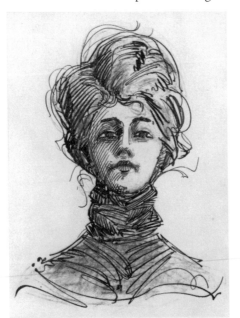

Study of a Woman's Head, c. 1903
Ink and coloured pencil on card, 9.25 x 8.75 cm
Tom Thomson Memorial Art Gallery, Owen Sound, gift of Fraser Thomson.
Photograph courtesy of Joan Murray Tom Thomson Papers.

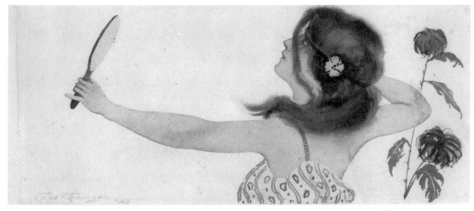

Girl Looking in Mirror, 1903
Ink on paper, 45.7 x 106.7 cm
Photograph courtesy of the
McMichael Canadian Art
Collection, Kleinburg.

useful, that he was a man who would "scrounge a bit of information, tuck it away, and bring it out weeks later…. He could listen with his eyes." Thomson's gift was a similar way of foraging, but, instead of state secrets, what he acquired and tucked away was information about art. The habit of picking up art information stayed with him. Much later, an Algonquin Park forest warden, Mark Robinson, noticed that while Thomson worked as a guide, he would listen to tourists' remarks on scenic views, and in this way catch their idea of what was worth painting. "Tom could talk with them or he could listen and gather in anything of interest," he observed. He was an accumulator of the impressions of others, an intellectual pack rat — like any artist worth his salt.

Seattle was a congenial town for Thomson. He was always happy and well-dressed there, wrote a brother. The two brothers enjoyed going to hear music at the theatres: "we nearly always were on hand early enough

to rush the gallery and get in the front row." He took his meals at the home of Maring, the head of the firm where he worked, but roomed at the nearby home of Mabel and P. Pitt Shaw and their three children, where he joined in musical evenings. Maring would come by to play the piano and Thomson played the mandolin or violin, or sang in his high, clear tenor. A large number of friends, also musicians, came to the house. He was drawn to the Shaw family. When he first went to inspect the room, he simply looked them over from the front porch and made up his mind — he felt no need to look further. They must have seemed similar to his family.

Seattle was a city of 80,000, the largest metropolis in the Pacific Northwest, lively and open. It was far more exotic than any place Thomson had known. By 1900 about a quarter of the population was of foreign parentage and almost a quarter was foreign born. It had one feature in common with Owen Sound. Like that

city, it had grown and prospered with the railway (the Great Northern Railway had arrived in Seattle in 1893). In the ten years from 1890 to 1900 its population had almost tripled, largely because of commerce and trade with the Yukon and Alaska regions, and increasing ocean traffic. From 1897 on, prospectors made a regular stop in Seattle on their way to the gold fields further north. With its bustling atmosphere, mild climate, and beautiful places such as Puget Sound to sketch and fish, Seattle pleased Thomson.

Dorothy L. Sayers's detective novel, *The Five Red Herrings* (1931), about a town in Scotland where landscape artists paint and fish, says that the two pastimes are complementary: "The fisherman-painter has the best of the bargain as far as the weather goes, for the weather that is too bright for the trout deluges his hills and his sea with floods of radiant colours; the rain that interrupts picture-making puts water into the rivers… and sends him hopefully forth with rod and reel." Thomson must have felt his situation was ideal, especially if he happened to meet the right girl. He wanted to settle down, advance in his trade, and marry — as his brother Ralph did in 1906, marrying the eldest Shaw daughter, Ruth. That Thomson did not was the result of his inability, already pronounced, to "get along," and what seems to have been a new sensitivity and a long-term propensity for having his feelings hurt — the common fate of those who try too hard to please.

The incident involves Alice Elinor Lambert, eight or nine years his junior. She had been born in 1886, in Corvallis, Oregon, eighty-one miles south of Portland,

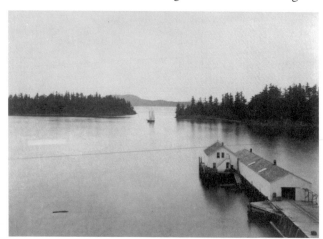

View of Puget Sound, Roche Harbor, Seattle, c. 1905. Photograph courtesy of Museum of History and Industry, Seattle.

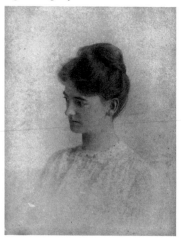

Alice Elinor Lambert, c. 1905, from a 2.57 x 3.27 cm photograph owned by Josephine Achimore, Berkeley, California; reproduced by Roy Hartwick, Oshawa. Photograph courtesy of Joan Murray Tom Thomson Papers.

in an area that was wilderness (ten miles from any railroad, she said later). Her father, Charles Edward Lambert, born in Ireland in 1843, had come to the U.S. before the Civil War and enlisted in the Union forces. After the war, he continued his studies in Latin and history and became a home missionary. In time, he married Nellie Carey Lathrop, who was in the same line of work. He went on to become president of Williamette University at Salem, Oregon, and then an instructor in Latin and history at Oregon State College. The couple had seven children, educated by Nellie at home — particularly in French, German, music, and wood-carving. Alice learned to love the Oregon woods — later, in her novel, *Lost Fragrance* (1933), she recalled the sweet smell of the hot sun on the wet ferns and the vanilla plants. About 1889, the family moved to Portland where for a year Alice attended high school; in 1905, still a student, she arrived in Seattle, and got a job as a saleslady. In 1933, a writer for a Seattle paper, inspired by interviewing Alice in person, imagined her as she was in 1913, fresh-cheeked, with dancing brown eyes, an eager smile, and a musical Irish lilt to her voice. A photograph of her in the *Portland Journal* in 1933 shows that she gave to the heroine of *Lost Fragrance* something of her own cheerful good looks. She described that character as follows:

> a tall slender girl whose close-fitting pale green sweater revealed a flat, young back, boyishly squared shoulders, high, rounded breasts. Widely spaced blue eyes, luminous and dark, looked out between lashes heavy as fringe. Her eyebrows were straight and heavy, unplucked. Hers was a high-bred English face, long rather than round.... Below her soft mouth with its full underlip, her square jaw ended in a deceptively pointed chin. It was a sensitive, fun-loving face, eager and gay, but with more than a hint of strength hidden in its soft contours.

Her background, rural but cultured, her love of adventure and the outdoors, and her energy must have attracted Thomson. He could be full of energy sometimes, but at others, he was darkly morose — as Alice wrote in *Women Are Like That*, a novel she published in 1934. A photograph exists that may be of the couple — it was discovered in a early sketchbook of Thomson's. Someone has written "Tom and Gals" on the back. Members of the family doubt that it is Tom, but the woman beside the man appears to be Alice. In the photo, she looks radiant while the man looks possessively fond of her as he rests his hand on her big hat. The other woman in the picture may be her friend Ruth Shaw. If the hypothesis is correct, the photograph may help to point up the difference between them — where he was shy, Alice was effervescent. He stares at the camera, she beams merrily.

31

Their romance followed a pattern typical of the period, and typical later of Thomson — one born of propinquity. It blossomed in the boarding house where he and his brother Ralph roomed, as did Alice on weekends. Alice later recalled Thomson standing by the piano while Mrs. Shaw played. One of his favourite songs, she said, was "In the Shade of the Sheltering Palms." She recalled him singing, and that the other boarders would beg him to continue. In *Women Are Like That*, she remembered him as tall, dark, and slender, with flashing eyes and nervous hand movements, and described how they liked to meet in downtown Seattle at Pioneer Square with its Totem Pole, ride the cable car together, or visit the public library where he would study the Old Masters — in books. Thomson was determined to succeed, she

claimed — and they were romantically involved. In a letter, she recalled how one night she fainted, and he carried her in his arms up to the third floor bedroom she shared with Ruth. He may have been a taciturn man, but nonetheless she was able to interpret his silence. "We knew without words that we loved each other," she wrote. "We had ESP, hardly needing words, and I know he felt the same toward me."

One story has it that it was the contrast between them that wrecked their relationship. They were in love; he did propose, but at the crucial moment, Alice, in sheer nervousness, giggled. In this version, Thomson, angered, went to the Shaws, packed his clothes, left for Toronto, and never returned. If the story is true, it was his sensitivity expressing itself again — for him, such untimely laughter meant ridicule: it was unacceptable

James Street cable cars at Second Avenue and James Street.
Photograph courtesy of the Museum of History and Industry, Seattle.

In Seattle, Thomson and Alice Lambert rode the cable car together.

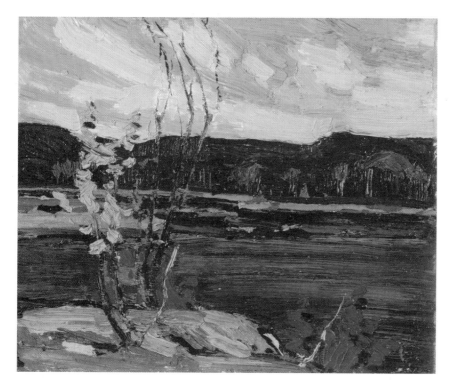

Autumn, Algonquin Park, c. 1916
Oil on panel, 21.6 x 26.7 cm
Private collection, Toronto

Spring, Algonquin, 1914
Oil on panel, 21.6 x 27 cm
Private collection
Photograph courtesy of Michel Filion
Photographe

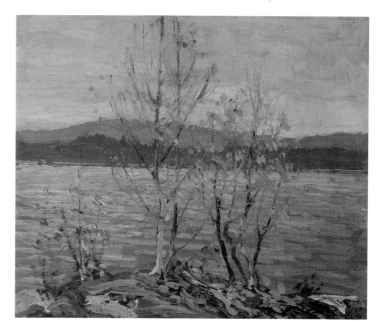

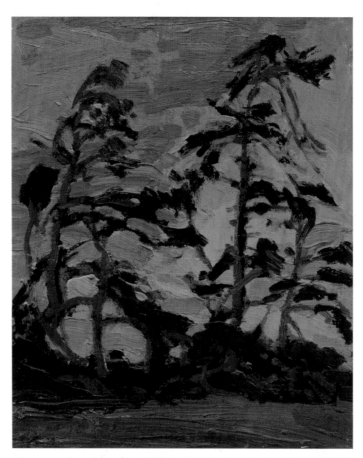

Evening, Pine Island, c. 1914
Oil on panel, 26.4 x 21.6 cm
Private collection, Toronto
Photograph courtesy of Joan Murray Tom Thomson Papers

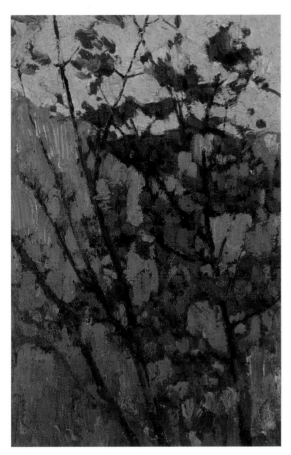

Soft Maple in Autumn, 1914
Oil on panel, 25.4 x 17.5 cm
Tom Thomson Memorial Art Gallery, Owen Sound
Gift of Mrs. J.G. Henry, 1967
Photograph courtesy of Joan Murray Tom Thomson Papers

Forest Interior, 1914
Oil on panel, 26.7 x 26.8 cm
Private collection
Photograph courtesy of Michel Filion Photographe

Northern River, c. 1914–1915
Oil on canvas, 115.1 x 102 cm
National Gallery of Canada, Ottawa
Purchase 1915
Photograph courtesy of the National Gallery of Canada, Ottawa

Footsteps in the Snow, c. 1915
Oil on pressed board, 21.6 x 26.7 cm
Private collection, Toronto

Algonquin Park, 1915
Oil on board, 21.6 x 26.5 cm
Tom Thomson Memorial Art Gallery,
Owen Sound
Gift of Mrs. J.G. Henry, 1967
Photograph courtesy of Joan Murray Tom
Thomson Papers

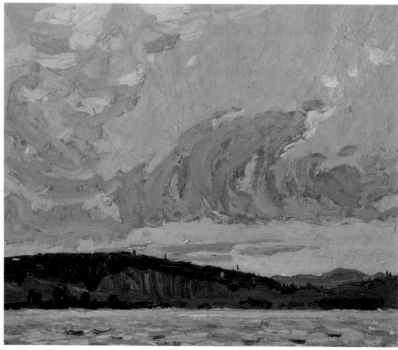

Morning, 1915
Oil on panel, 21.1 x 26.5 cm
Tom Thomson Memorial Art Gallery,
Owen Sound
D.I. McLeod Bequest, 1967
Photograph courtesy of Joan Murray Tom
Thomson Papers

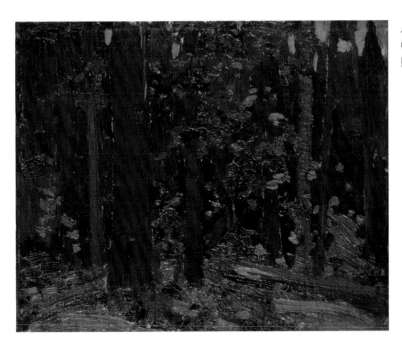

Autumn Woods, Algonquin Park, 1915 or 1916
Oil on panel, 21.6 x 26.7 cm
Private collection, Toronto

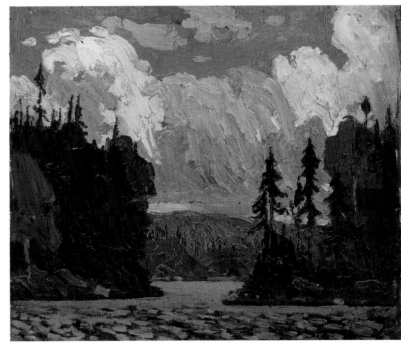

Black Spruce in Autumn, c. 1915
Oil on panel, 21.7 x 26.8 cm
McMichael.Canadian Art Collection,
Kleinburg
Gift of Mrs. W. Tweedale, Toronto, 1966
Photograph courtesy of Joan Murray Tom
Thomson Papers

Evening, Canoe Lake, c. 1915–1916
Oil on canvas, 41.3 x 50.8 cm
Private collection, Toronto
Photograph courtesy of Joan Murray Tom Thomson Papers

to his fragile ego. He may have felt emotionally wounded — or perhaps he decided Alice was immature and giddy.

Alice told another, more melodramatic story. This story involves a friend and roommate of Tom's, Horace Rutherford from Owen Sound. Rutherford falsley told Thomson that he and Alice were engaged. According to Alice, Tom forced Rutherford to go with him when he left Seattle. Alice still called Rutherford a "swine," even sixty-five years later. In this version, Thomson meant to save her. Thomson's behaviour in Seattle cast

Horace Rutherford and his father David, c. 1903. Photograph courtesy of D.W. Kibbey, Spokane, Washington.

a light on both his sensitivity and chivalry, a relative said later, so both stories probably have elements of truth. But though what happened is garbled, the result is clear. As Lambert put it later, Thomson "fled" Seattle. To leave, of course, was his typical response to incidents that made him angry. With Lambert, the reaction was particularly sad. He never seems to have written her. Curiously enough, though she longed to write him, she did not get in touch with him. "Unversed as she was in the art of pursuit and capture, she had let him go, powerless to hold him or call him back," she wrote of his going east in her 1934 novel. Perhaps she was embarrassed over what happened, or perhaps other events hindered her. "A miserable incident prevented me," she wrote in 1971. Yet she grieved over losing him; he broke her heart, her friend Ruth wrote later. At age eighty-five, Lambert still regarded Tom as the person she had truly loved, and the two of them as star-crossed, young, and innocent people who never should have parted. "For years I have planned to go to wherever he was buried, to lay a red rose on his grave," she wrote.

In 1915, with her husband, Joseph E. Ransburg, who worked in the clothing business as a "cutter," Alice and a baby girl returned to Portland. She stayed there till 1922, living in the Rosepark area (a working class section) where her youngest daughter was born. Then she separated from her husband, and with her children, a new hat, and fifty dollars (as she later told

newspaper interviewers), she set out for San Francisco. For the next two years she wrote an "Alice Elinor" column for the *Examiner*, one of the papers in the Hearst newspaper chain. It followed that she returned to Seattle to work at a similar job. In 1931 she moved to New York, returning to Seattle the following year to work for the *Post-Intelligencer*. At the same time, she wrote three novels for Vanguard Press, reprinted in the 1940s and 1960s by Dell. Her philosophy, she said in 1981, a year before her death, was to read from the book of life, and tell others what she found there, though she might embroider if she wished. Her books, light novels of the day, are filled with beautiful and madcap women: their stories end happily. If she introduces a man who is a heartbreaker, he has one difference from Thomson: he kindly explains to the heroine why he can't "stick it any longer" instead of leaving her to wonder forever what she did wrong.

In leaving Seattle and Alice, Thomson may have felt he had lost something hard to define, yet substantial. At the back of his mind, he probably felt he might have had a happier life — or at least a different one. He had lived among friends, earned a good wage in congenial surroundings, even met a girl with the same tastes and interests, and perhaps the potential to be his wife. These were circumstances difficult to repeat. He also liked his adopted country. Later, back in Canada, in Toronto, when he heard the band play "The Star-Spangled Banner" at a concert,

he stood up and, with respect, took off his hat. "By God! I like the country better than Canada," he told friends in describing the incident.

As though to make up for what he had lost, and perhaps even to assuage what we may think could have been dark thoughts, Thomson chose to follow a new path — likely to follow an earlier dream. When he came home from Seattle, Thomson decided to be an artist. Today, when someone has such a turning point in life we define it as a reinvention of the self. Thomson's reinvention took a long time, almost a decade, but he achieved his goal: by 1914, he had become a painter. What happened to him in Seattle also gave him a secret — perhaps a sense of failure, or a desire to be wary in emotional matters. Coming at a time when he was breaking out of post-adolescence, his new freedom whetted his appetite for adventure. He became a risk-taker, at least in his heart.

Toronto: Opportunity Knocks

3

To become an artist in 1905 meant training, just as it would today. Presumably, this training would involve attendance at an art school. Thomson had never had the education he wanted, and he knew that now he would have to provide his own education in art. First and foremost, he had to get a grip on himself, as his father would have said. He was twenty-eight, and he needed a job so he could provide for himself. In Ontario, this meant that he had to live either in Toronto or nearby Hamilton, where there were jobs for designers or artists with his background — and art colleges. Apparently, he worked briefly in Hamilton at Reid Press, but mostly, he lived in Toronto, the biggest city in Ontario, in a series of boarding houses in the heart of the downtown. One of the first jobs he held was as senior designer at Legge Brothers in 1905. His pay, eleven dollars a week, was modest — far less than he had earned in Seattle. But, as he kept his personal expenses to a minimum (he ate chop suey every night, he told Stuart L.

Thompson, an apprentice at the company), he made ends meet. Toronto had one advantage over Seattle. On Saturdays at noon, when he finished work, he could take the train to Owen Sound, and from there "tramp" the eleven kilometres home. He would arrive late at night, a family member recalled. They would hear his whistle and rush out to greet him. He spent other weekends much as he had in Seattle, sketching with friends from commercial art firms in picturesque spots around Lake Scugog, east of Toronto, or along the Humber River in Toronto's west end.

Thompson recalled that, in the office, Thomson sat next to a window — an indication of status. "He was tall, lanky ... slow, deliberate, quiet and friendly and temperamental," Thompson said. "We boys liked him and looked up to him." His type of work was general illustrating. "Tho careful with his work he dressed indifferently," Thompson later wrote (a significant change from the Seattle Thomson). "Once he washed his hands by simply throwing his art water over them, letting it run freely onto the floor." Recognizing his way of playing to an audience, Thompson noted, "He was very moody ... subject to fits of depression which I think he played up largely."

I recall once he threatened to quit and leave town, saying he was "down at the yards looking at the freight trains going east last night." The joke being that freight trains did not wait 24 hours in the yard and any freight would do. Another time he announced that he was going to quit all his bad habits and straight way threw his pipe matches and plug of tobacco out the window into the street. He was smoking next day. Occasionally he would drink too much when he would become morose and

Tom Thomson, c. 1905
Studio portrait photograph by W.D. McVey, Toronto.
Photograph courtesy of the Ontario Archives, Toronto, S2794.

When Tom returned to Toronto after Seattle, he decided to become an artist. A new intensity appears in his face.

go home. Once he drank enough to quit and stayed away. I understand he phoned in and said he was getting another job and requested the boss not knock him when asked for reference.... He was always courteous and helpful to us boys and had a strange way of calling out "which?" if he did not hear a remark instead of "what" or "pardon."

Thompson, besides revealing quirks of Thomson's behaviour, suggests that he would sometimes drink. We conjecture that he may have been unhappy at his job, or with his life and prospects, or all of them together. Once he was in a better place, living under better circumstances, he seems to have brought the problem under control; at least, we hear no more about it for the next few years. Yet incidents with alcohol were to recur in his life, underscoring moments of difficulty like a musical refrain.

Toronto, then with a population of 225,000 people, was almost three times the size of Seattle, and offered what seemed unlimited opportunities in commercial art. Canada was fast becoming an industrial nation. The need for images that advertised new goods was inexhaustible. Revenues were increasing, money was flowing — much of it from the very profitable railways — and advertising was proliferating: posters were needed, and advertisements for hotels, tourist camps, and steamship lines. The commercial

artists were the smart young men of the day, and by 1912 Thomson's flair for design had apparently put him in a good financial position. For a while he became a dandy, wearing the latest fashion: peg-top trousers, and "dude's shoes." A drawing by Lismer catches him thus, but his stylish dress was only a temporary aberration, worn no doubt to amuse friends. Soon he was back to his old careless way of dressing.

These golden years of commercial engraving in Toronto attracted most of the innovative graphic-design talent in the field, much of it Canadian born. In this milieu, Thomson's ability was immediately recognized. Art directors were struck by the intelligence of his work; fellow artists by the fun they had when he was there. The impression he made was of a graceful individual, but his friends were beginning to realize that, for all his charm, he was extremely reserved. New stories underscore what we already know of his taciturnity, his dour nature, his silences.

He wasn't lonely outside his job. He had found a new girlfriend, "arty" Elizabeth McCarnen, who went with him to dances. In 1906 he began to study art seriously. In the evenings, in a class compatible with holding down a full-time job, he studied drawing at the Central Ontario School of Art and Design. One of his teachers was the Scot William Cruikshank, then in his mid-fifties. He had trained in Edinburgh at the Royal Scottish Academy, and in London at the Royal Academy School, and mostly taught drawing, though

37

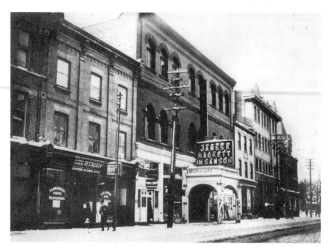

The Central Ontario School of Art and Design, 1910, south side of King St. West, between York and Simcoe streets in Toronto. (The school held its classes upstairs, above the Princess Theatre.)
Photograph courtesy of Metropolitan Toronto Library Board (Rep.B5-30b).

Young Man with Team, c. 1906
Oil on canvas, 27.9 x 38.1 cm
Private collection, Toronto.
Photograph courtesy Joan Murray Tom Thomson Papers.

His first oil paintings were amateurish, but his teacher, William Cruikshank, looking at this sketch, recognized his talent, and told him he'd better "keep on."

his deepest interest was in painting. *Ploughing, Lower St. Lawrence* (c. 1898), which he painted for an exhibition, reveals his fascination with the paintings of Jean François Millet as well as his attention to what was characteristic in the landscape of Canada: these are figure subjects of habitants set in rural Quebec. Thomson would have known of Cruikshank's interest, and his habitual desire to please probably intensified by the fact that Cruikshank was such an important teacher, created in response what was probably his first oil painting — naturally enough, of a ploughing subject. Still, he did it his way. He may have used

Cruikshank's idea, but he delved into his own memory for the image of the man standing by a team of horses and plough at dawn. The result, though modest, succeeded in attracting the teacher's attention. When Cruikshank saw the small, garishly coloured oil, he told Thomson, "You'd better keep on." Like others, he recognized Thomson's talent. Luckily, Thomson followed this introduction to art with a new job, which gave him more training. From apparently running his own small design business, in 1908, he joined Grip Limited, a well-known commercial art firm.

Grip was named for the cynical raven in Dickens'

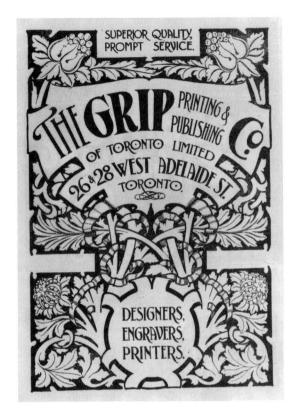

The Grip advertisement, *Canadian Almanac and Miscellaneous Directory* (Toronto: Copp Clark, 1901), 391.
Photograph courtesy Joan Murray Tom Thomson Papers.

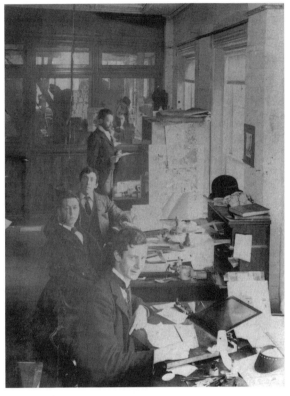

Grip Limited, c. 1910
Photograph courtesy of Joan Murray Tom Thomson Papers.

From 1908 to 1912, Thomson worked at the commercial art firm of Grip Limited in Toronto with artists such as Franz (then Frank) Johnston, F.H. Varley, Arthur Lismer, and Franklin Carmichael (later, they were members of the Group of Seven). At Grip, Thomson worked in J.E.H. MacDonald's design section. In the foreground of this photograph is MacDonald, Tom's "boss," whose desk was famous for its untidiness; all the desks look untidy, however.

novel *Barnaby Rudge*, the same raven used in the flag and name of *Grip Weekly*, a newspaper of political comment established in 1873 by the Canadian cartoonist John W. Bengough. To make engravings for this paper, the company established a small engraving department that rapidly grew to serve other newspapers and commercial houses. Though *Grip Weekly* discontinued publication in 1884, its art and engraving department continued to flourish.

When Thomson joined Grip, the company was at an ambitious stage of its development. Much Canadian advertising business had been placed with agencies and commercial artists in New York, and Grip aimed to break into the market by offering art work of a competitive quality. It engaged a good art director, A.H. Robson, and a painter, J.E.H. MacDonald, who was considered the anchor of the design team — a "winner." Robson hired Thomson and placed him under MacDonald. Though Thomson was just four years younger, he was always to treat "Mr. MacDonald" with respect. Robson was to recall the dark blue serge suit and grey flannel shirt Tom wore to the interview, his clean-cut, almost classical features, and the mop of black hair he had combed down over his right forehead. He wrote that

There was something intriguing about Thomson, a quiet reserve, a reticence almost approaching bashfulness. There was no bombast or assertiveness as he handed me a

bundle of his work… His samples consisted mostly of lettering and decorative designs applied to booklet covers and some labels. A quick glance at his drawings revealed something more than mechanical and technical proficiency; there was feeling for spacing and arrangement, an over-tone of intellectual as well as aesthetic approach to his work.

One of the booklet covers Tom showed him may have been a design he made of a woman's face and bust

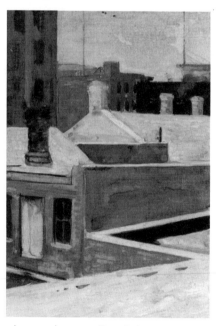

View from the windows at Grip Ltd.
Watercolour on paper, 14.9 x 10.2 cm
Private collection.
Photograph courtesy of Joan Murray Tom Thomson Papers.

This sketch was found in Thomson's sketchbox after his death.

40

in profile. She wears a headband of maple leaves in her hair. It was an attractive tribute to Canada, and had been used on the cover of a Canadian home magazine.

It was at Grip, under MacDonald's tutelage and encouragement, that Thomson's genius began to flower. The tall, slender Scot with reddish hair had much in common with Tom — he too was shy, humorous, and a brilliant designer. Like Tom, he loved nature and literature; he even wrote poetry. Tom must have found him intoxicatingly full of information, and must also have realized that MacDonald was far ahead of him, since he had worked in England in 1903 for a top firm of the day, Carlton Studios, and knew what was going on in commercial design abroad and in North America.

Art, architecture, and design journals had proliferated during the second half of the nineteenth century in America. These magazines felt their mission was to create an international style of design. *The Studio* magazine, published in England since 1893, and *Jugend*, were only two of a group of wide-ranging periodicals to which MacDonald subscribed, or to which he had access through friends or the excellent Toronto library system. MacDonald followed with intense interest such magazines' coverage of the latest developments in work of artists in Germany and Austria, in Britain of designers such as William Morris, in Scotland, Charles Rennie Mackintosh, or in the United States of the Arts and Crafts movement, and particularly Louis Comfort Tiffany.

Tiffany had begun his studies as a painter with the American landscape painter George Innes in 1866, and always seemed to have in mind the medium of painting when he created stained glass — hence his power as a colourist, and the strong design quality in the lead elements of his floral and landscape windows. He created his first opalescent ornamental glass window in 1876, and always was most interested in this area of his work, though in time his contribution extended to the entire field of decorative arts. In 1913, a catalogue issued by his studios illustrated windows he had personally supervised. MacDonald and Thomson would have been delighted with such a publication; they would have responded strongly to Tiffany's love of nature. The idea of using landscape themes for ecclesiastical and domestic settings would have struck them as inspired, for in nature they saw evidence of God, just as did the nineteenth-century Romantic poets.

MacDonald was less familiar with developments in the fine arts but knew about Art Nouveau, the name adopted for the "new art" style that had appeared in France toward the end of the nineteenth century and rapidly spread throughout Europe. Its aim was to express a modern sensibility through design inspired by nature. Often asymmetrical, the refined patterns of Art Nouveau were inspired by Japanese models. Through such examples, MacDonald would have helped to provide Thomson with what he badly needed, an education in the design and art field. His

help may have reminded Tom of the open-handed, open-hearted generosity of his family, but this time applied to the world Thomson found most fascinating, the modern age in decorative art.

Some of MacDonald's ideas are still powerful today. A decade after he had told Thomson his thoughts, in a lecture at the Ontario College of Art in Toronto, MacDonald spoke of design as involving rhythm, balance, and harmony. For him, an idea had to have an organic quality to be good design — a feeling of growth, as well as proportion, spacing, and rhythm. Walter Crane's *Of the Decorative Illustration of Books Old and New* (1889), a book MacDonald admired, clearly pointed out the importance of good design. Crane believed in a unified composition of type, illustration, and ornamental border — a crucial idea that MacDonald would have shared with Thomson.

Gradually, under MacDonald's influence, Thomson began to be more than just a craftsman. In his illustrations for advertisements, he began to use scenes from nature. But behind the design lay a new philosophy. We can sense his source of inspiration if we look at the illustrations he created apart from his job, inset with homilies or quotations from famous authors of the day. They have bordered, block-set decoration, a medieval air, and heavy, old-style type, all

echoes of books or magazines that Thomson and MacDonald read. For instance, to draw his own version of a knight in shining armour, Thomson might have studied illustrations by William Morris, or items of special interest such as volume One, number one, of *The Knight Errant* from the Elzevir Press in Boston. The latter was, as one of its editors said, a model of typography and the printer's art. A milestone in the American revival of fine printing, it would have been well known to Thomson and MacDonald. The 1891 cover by Bertram Grosvenor Goodhue shows an armoured knight to one side, looking towards an

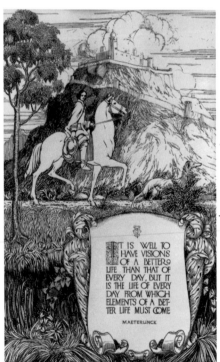

Quotation from Maeterlinck, c. 1908
Ink on paper
32.6 x 18.5 cm
McMichael Canadian Art Collection, Kleinburg. Photograph courtesy of Joan Murray Tom Thomson Papers.

Gift to the artist's mother and father at Christmas.

IT IS WELL TO HAVE VISIONS OF A BETTER LIFE THAN THAT OF EVERY DAY, BUT IT IS THE LIFE OF EVERY DAY FROM WHICH ELEMENTS OF A BETTER LIFE MUST COME

MAETERLINCK

Italianate castle atop a distant hill. There are resemblances in Thomson's knight, but his hero is more youthful, more naive. In sketches like this he was no doubt trying to satisfy MacDonald and the other designers at Grip. He would have submitted such work for their criticism. He also brought to them, for advice, sketches he had painted on weekends. MacDonald, and men such as Robson, who was a member of the Toronto Art Students' League, an early arts group, would have looked for and praised the truth to nature in Thomson's work.

The next step in Thomson's development occurred after a camping trip to the Mississagi Forest Reserve in 1911. Thomson was told by his friends at Grip that his sketches, with their vision of the north, had "it" — the real northern character. He returned to the firm to which Robson, and then all of them, had moved in 1912 — Rous & Mann Limited — with work that, they agreed, showed a tremendous advance. These sketches were his real start as an artist.

From this time until Thomson's death it would be only a short five years. That the thirty-five-year-old could produce work which proved to be so significant for the history of Canadian art seems miraculous; this remarkable outcome was the result not only of his ambition but of the comradeship of a close group of men.

It was his loneliness that brought his ambition to the fore at this time. Most of his family and old friends were far away. When he moved to Toronto from Seattle, his brother Ralph had stayed behind to marry Ruth Shaw. His brother Fraser stayed in Seattle too, and Minnie, Tom's closest sister, married in 1907 and moved with her husband to Saskatchewan to farm. In 1906 his eldest brother, George, had gone to the United States to study art, first to the Art Students' League in New York City, then to Connecticut to study at an art colony, in Old Lyme; in 1908 he moved to New Haven to work as an accountant, and make art "on the side." Brodie died in 1909, so Thomson could no longer visit with him. To cap it off, that year his girlfriend, Elizabeth McCarnen, left Toronto for Phelpston, Ontario, to live on the family farm and help care for the four children of a brother and sister, both of whom were widowed. As a result of all these deaths and departures, Tom would have felt at loose ends. Grip must have seemed a second home to him, and MacDonald, so knowledgeable and yet so comforting, with the light-hearted twinkle in his eye, may have seemed something of a father, though a more hard-working father than Thomson had known. Now, from his position as foster son in this new family unit, he rose again: to the position of artist.

43

Tom Thomson, 1912–1913, by Arthur Lismer (1885–1969)
Pen on paper, 25.1 x 30.2 cm
McMichael Canadian Art Collection, Kleinburg.
Photograph courtesy of Joan Murray Tom Thomson Papers.

Northern Chronicles

4

Every artist brings gifts to place on the altar of art. Like the Magi at the birth of Christ, each brings a different offering — some favoured colour, some experiment — others rediscover an Old Master technique. Thomson brought family heirlooms to his art. They were little enough, and not particularly adapted for the purpose, like a Swiss army knife at a feast, but they were all he had: his Cousin Brodie's knowledge of nature, the Thomson family's love of literature, and his father's ability to concentrate. Yet these habits proved useful; one of the ones that served him best was the ability to concentrate. We know from his brother Ralph's account of Tom in Seattle that he was a quick study. As he began to take painting more seriously, he began to draw on this strength. A friend at Grip, L. Rossell, described his progress as follows:

After he started painting ... the subject seemed to absorb him to the exclusion of every other interest. This is, I think, one reason why his progress was so phenomenal. He would, while the rest of us were having a good time at parties, theatres, etc., be working away ... He did what so few are able to do, concentrate on one thing.

Arthur Lismer, an artist from Sheffield, England who joined Grip in 1911, drew a quick sketch of his absorbed colleague while Thomson was in the throes of artistic inspiration: it shows his total preoccupation. Lismer's intent was to tell a comical story. As Thomson draws with the artist's quill pen, the ink bottle has tipped on his desk. The sketch unintentionally demonstrates Thomson's charisma. Even across the years the power of his personality impresses.

By now MacDonald was on his way to becoming a professional painter, with a show of sketches in Toronto at a favourite Grip hang-out, the Arts and Letters Club. In a review in the December 1912 issue of the occasional magazine of the club, *The Lamps*, C.W. Jefferys — himself a painter, commercial artist, and club founder — praised the show's native quality. It derived, he said, from MacDonald's themes — rocks, snow, pine trees, lumber drives.

Another club member was Lawren Harris. Later, he recounted how MacDonald's show drew him to MacDonald. Harris, too, wrote in *The Lamps*, crying out for a new version of Canada in Canadian painting, "... a true Canadian note, not so much in choice of subject as in the spirit of the thing done." Freshness, vigour, and originality counted the most, he said — and MacDonald had these qualities. He also believed a painting should be a unity: "One

Arthur Lismer, *Tom Thomson at Grip Limited*, 1912
Pencil on paper, 19.7 x 21.3 cm
Photograph courtesy McMichael Canadian Art Collection, Kleinburg.

The affection Tom's co-workers felt for him is evident in this sketch, where Lismer has deftly indicated his reaction to sudden inspiration. Note the lock of hair falling over his forehead.

believes a masterpiece must be a unit, a little world, and that this is one of the great secrets of all art of all time." What this meant would not have been hard for Thomson to understand, since it sounded like Walter Crane's idea. What mattered most about Harris was that he had such belief in MacDonald that he encouraged him to simply paint, giving up his commercial work; he even offered to finance the idea. MacDonald, delighted, agreed.

That year, Harris, MacDonald, and Thomson were fascinated by a new star in their midst — A.Y. Jackson. At the Ontario Society of Artists show of 1911, the trio stood in front of Jackson's painting *The Edge of the Maple Wood* in enthusiastic agreement about its quality. The scene of springtime in the woods had the feel of a real Canadian season, they reasoned. The landscape was wet and sodden, and sap pails hung on the maple trees. The final effect, they felt, was natural, simple, and unpretentious. It suited their own unvarnished personalities and preferences, both in art and in life.

The result of the ferment around him was that Thomson began to take painting more seriously. In 1911 or early 1912 he bought his first painting outfit, an ingenious box with grooves on the inside, into which he could slide panels; he could carry it with him, stop at any place he chose, and paint on the panel. Characteristically, this man who so wished to please selected a place to paint that fulfilled (it seemed by chance) what Harris had said was needed.

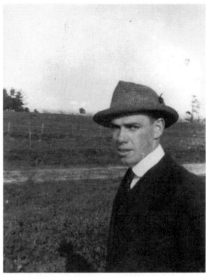

Photograph of William S. Broadhead.
Private collection.
Photograph courtesy of Tom Thomson Memorial Art Gallery, Owen Sound.

In 1912 Thomson went on a two-month canoe trip to the Mississagi country with William S. Broadhead. It was his first serious sketching. Sketches from this trip, such as Mississagi, were low in tone, simple in format.

Thomson went searching for a true Canadian location — he found it in the north.

He went there to fish, but we know from a brother's account in Seattle that where Thomson fished he painted. And once he began to paint he usually forgot about the fishing. Now, in 1912, on the advice of a friend at Grip, Tom McLean, he made a trip to Algonquin Park with H.B. Jackson, another Grip colleague. Later that year, in August and September, he took an extended trip to the Mississagi Forest Reserve further north with yet another Grip employee, William

S. Broadhead, a gifted artist. The following year he returned to Algonquin Park. On all of these trips he painted, though at first his work consisted only of colour notes. It was on the trip to the Mississagi Forest Reserve that he began to sketch in earnest.

The sketches we have from the trip are small and few, but they are painted with meticulous care. Some see them as dull student efforts, but they are tremendously important to the history of the later Group of Seven. What was so different about them was simply the subject. They lay before us the wilderness through which Thomson and Broadhead travelled, a land of rocks, water, and pine trees in various stages of growth or decay. Sometimes we see only the opposite shoreline and seem to sit with the artist in a canoe in mid-lake. Sometimes we look at an upturned canoe on a rocky, overgrown shore, perhaps the site of an old lumber dam. The skies are grey or cloudy. Only rarely do we find a sunset, indicating good weather, and we know from a newspaper account of the trip, drawn from an interview with the two artists, that it often rained. According to the reporter, the canoe spilled and they lost most of their good sketches (or so they said). The few that remain are of high quality. They look surprisingly modern. What Thomson painted was only a section of the view — the land seems to continue behind and beyond the frame. We see parts of an area of a wilderness expanse, a great world, shiny, and, it seems, untrodden. A particular kind of sensibility is portrayed: blunt reportage. Thomson made no attempt to give his composition a central point; the scenes are often cut off on two sides by the borders of the sketch. The sense of limitless vista prefigures that of the later Group of Seven. These works that he showed to his friends in October were to be crucial to his — and

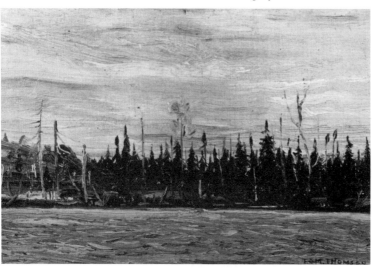

Mississagi, 1912
Oil on panel, 17.5 x 12.5 cm
Private collection.
Photograph courtesy of Joan Murray Tom Thomson Papers.

The first sketches in which Thomson used themes common to his later work were painted on a trip to the Mississagi Forest Reserve.

their — development. It was through these sketches that Thomson came to the attention of a new friend, Dr. James MacCallum, an ophthalmologist who canoed and travelled extensively in the north, and who had a cottage on Georgian Bay. In time, he was to become Thomson's first patron. Through these sketches, as well, Thomson became who he was — Tom Thomson, one of Canada's heroes.

Thomson's selection of Algonquin Park as a painting site rested on strong family roots. As a "Brodie boy," one of the men inspired by Dr. Brodie, he would have heard how the Natural History Society, through the Royal Canadian Institute (with which it amalgamated in 1885 to become its energetic biological section), had agitated in 1886 for the formation of a National Park for the preservation of Canada's wild animals. In 1890, the government appointed a Royal Commission on Game and Fish that submitted recommendations, one of which concerned the formation of a Provincial Game Park to serve as a wildlife sanctuary. The advice was acted on: one week after the report was tabled in 1892, the government appointed another Royal Commission in preparation for establishing Algonquin Park. Throughout the period that the Park was coming into existence — the Act to establish it was passed in 1893 — the Canadian Institute continued to remind the government of the need for its existence. From 1887 to 1888 and from 1891 to 1892, Brodie was a member of the council of the institute; he must have helped frame the representations the association made to the government of Ontario. After its creation, with other naturalists, Brodie systematically explored the natural habitat of the park, particularly the insect life. (He made plans to make a visit to the park in 1906, three years before his death, as we know from his correspondence in the library of the Royal Ontario Museum.)

When Thomson went north, his connection with Brodie would have given him a special feeling about the park. Deep in his being, the north spoke to him of matters in which he had long hoped to achieve a career. Now he began to visualize a way to fulfil his old desire.

He also recognized what we could call the advertising potential of the park. It was of great value to the public because it had only recently been created; the establishment of boundaries set off the area as unique. In *Landscape and Ideology*, Ann Bermingham explains why, at certain historical moments, landscape painting expresses the needs of a whole culture. She speaks of the enclosure of the English countryside as a critical element in the English Rustic painting tradition from 1740 to 1860. Perhaps Thomson fell upon the imagery of Algonquin Park so avidly because the park was "newly enclosed." The more than five thousand square kilometres of forest, lake, and river had been set aside as a conservation area. The idea was different from the way the commons were created in England;

here, enclosure meant not to drive people off common land but to preserve wilderness. Bermingham argues that the landscape allows what is erased (here, open land) "still to stand as an informing presence." The park was and is what we take to be wilderness, and its being set apart guaranteed that this region would be accessible, in perpetuity. In this defined space, Thomson could shape a new imagery that spoke to an audience eager for knowledge.

But, on one hand, if he acted as an explorer and interpreter, on the other, he acted as a person who had decided to adopt as an alternate to urban life — "the simple life." In the long hours he spent at commercial art, he must have entertained an escape fantasy — we know that he told the assistants in one shop that he wished that he could take a train somewhere, anywhere. Now, by taking a train to go fishing, he lived out a version of his dream.

Thomson's family valued fishing and hunting, and from childhood, he had loved to fish. From an early date, too, he had been fascinated with native life; in a sketchbook dated around 1906, he drew Indian tools and moccasins. He must have felt intense curiosity about the exotic. In 1961, journalist Trent Frayne uncovered an early incident in his life involving long hours he spent at the Canadian National

Exhibition, absorbed by a sideshow of African natives in a simulation of their natural habitat. A woman acquaintance recalled, wrote Frayne in *Maclean's*, that they stayed at the sideshow three and a half hours while Thomson watched it. Only afterwards did they visit the art section of the exhibit to stay there untill it closed. Thomson and his friend returned to the CNE four more times. On each visit, he repeated the routine he had first established.

Frayne's article is riddled with errors, so we cannot be sure his account is accurate. For example, he wrote that Thomson lived for ten years with the family of Joseph Watson on Elm Street in Toronto (we imagine that this is where he met the woman friend of the

Photograph of Tom Thomson at Fairy Lake, Algonquin Park, with friends (Tom in bow of boat, Miss McRuer next to him, Dr. McRuer and wife in stern).
Private collection.
Photograph courtesy of Joan Murray Tom Thomson Papers.

50

story). Yet from the city directory, we know that he lived on Elm Street only from 1906 to 1908. However, the visit to the CNE does have a ring of truth. It seems to fit with what we know of Thomson — at least from hindsight.

Certainly his decision to go north had a quality to it of "going native," though as we can tell from photographs that show the way he dressed in Algonquin Park — roughing it in outdoors clothes — "native" for him meant the lumberjack and woodsman, not the Indian.

The decision to go north also had unexpected results. Part of Thomson's escape fantasy would have involved the thought of regeneration; that from the time spent in nature, he would return refreshed, not only as a man — but as an artist. As it turned out, his dream came true. His art did go through a sea change towards something fresh and new.

That art, and the photographs he took, were his way of appropriating what he saw, bringing it home with him to remember at a later date. Ironically, such photographs as we have document the difficulties of the north as a painting site. Though his fantasy may have been of a wilderness, it is clear from his own photographs of Algonquin Park that it had been heavily logged. They are documents. Some record his camping, fishing, canoeing, and friends; others are evidence of his naturalist's bent: we see a beaver, beaver dams, a ruffed grouse, a loon's egg, a squirrel

seated on his sweater. In a way, these are souvenirs, picture postcards of a place seen through the eyes of a Brodie boy.

In interpreting what he saw in his paintings, Thomson reached far beyond the photograph, developing Algonquin Park into a world of rhythmic repeats, of trees, bush, and lake at different times of day and at different seasons. He deliberately constructed the scenes he selected from images that spoke to him through his training as a designer; in doing so, he served his art less as a realist than as a visionary. He built symbols not only out of lived experience but used it as a stimulus for what he knew from his background in commercial art would make good art. He saw the land as generating a distinct emotional rhythm and he conveyed what he felt. He was a naturalist and a designer, and like his uncle and others of his day, saw in nature evidence of a great design everywhere he looked; but since he loved the land and painted it, he became an "environmentalist" — one of the first, even if he did not know the word.

Yet it was the journey through the wild country that acted as the shaping fact of his imagination. To arrive at some natural destination is a "kind of fiction, the illusion of an end," Salmon Rushdie wrote in an essay, "On Adventure." Thomson lived through a real-life adventure, and made his pilgrimage in search of enlightenment. His sketches suggest he found what he sought. The enlightenment lay in two things. On the

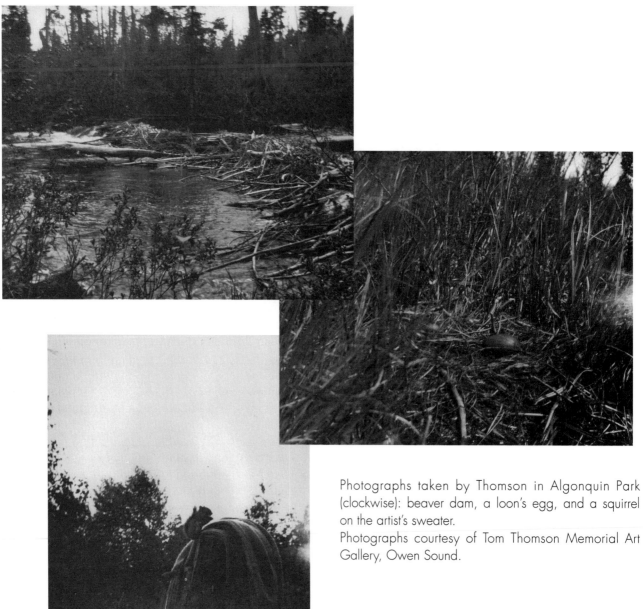

Photographs taken by Thomson in Algonquin Park
(clockwise): beaver dam, a loon's egg, and a squirrel
on the artist's sweater.
Photographs courtesy of Tom Thomson Memorial Art
Gallery, Owen Sound.

one hand, he discovered a new place to paint, and hence new imagery, but the best part lay in the inner journey, the expansion of the way he learned to paint. "Few topographical boundaries can rival the frontiers of the mind," Rushdie wrote. Part of the adventure was the story of his friends, who, recognizing his discovery, drew together to help him transform his sketches into his first professional painting.

The steps they took helped him on the path he wished to follow; what they told him involved the practice of art as they knew it. They realized that he had to have a studio. Robson gave him the keys to the office on weekends so he could work there, and Thomson took full advantage of the time and space provided.

He selected a likely sketch from the group he'd done on his trip — one with a simple, effective composition, easy to develop. The scene he chose was a view of a

lake framed by trees on either side; in the foreground lie branches piled on rocks. No doubt unconsciously he settled on a subject that looks like a stage set, except that the boards where the players would have acted is lake water blown by wind. To the canvas, *A Northern Lake*, he added one change — a powerful row of foreground rocks, which shield most of the shoreline. The idea was probably inspired by MacDonald's type of composition; he always favoured a built-up foreground, and liked to use, as a device, what art historians call a *repoussoir*, or an object that sticks out and makes the viewer look over it into the picture. It is a way of establishing depth and also, like an arrow, helps to lead the viewer's eye where the painter wants them to go. The branches Thomson laid before his rocks point the eyes his way. His problem lay with the rocks: he seems not to have known how to paint them.

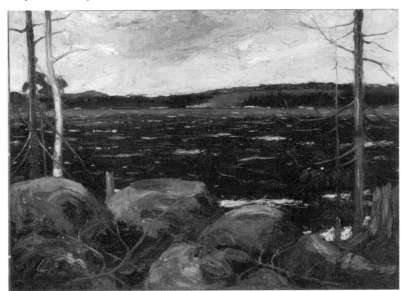

A Northern Lake, 1913
Oil on canvas, 69.9 x 101.6 cm
Art Gallery of Ontario, Toronto.
Gift of the Government of the Province of Ontario, 1972.
Photograph courtesy of Joan Murray Tom Thomson Papers.

For technical advice, he likely turned to a newcomer to Grip, Frederick H. Varley, who had arrived in 1912 and quickly became one of the team. Varley, like Lismer, had been trained at the Sheffield School of Art. He saw rocks, and indeed all of nature, as a design problem and as something organic: two ideas which would have chimed in with Thomson's. Probably it was Varley's idea to treat the rocks as powerful vortexes of energy, and to paint a first layer, a thin mix of wash and oil paint with turpentine, then cover the dried layer with paint put on with the palette knife. He may even have taken the brush from Thomson's hand to show him how to carry out his advice (later he told a friend he had helped with a technical problem). The reason we suspect Varley's hand in the rocks is that they look like rocks he painted later, from 1927 to 1928, in his monumental canvas Sphinx Glacier, Mt. Garibaldi. The dramatic, sweeping forms are the same, as are the attention to shadows and the strongly designed circular sides and tops. His rocks are like his handwriting, distinctively his. Thomson never painted rocks like these again. Once he absorbed information from Varley, he moved on in the manner usual to him, developing his own solution.

The way Thomson drew upon help from his peers is a measure of his aspiration as well as of the positive energy released in him by their praise. The result was a huge leap forward — the creation of his first assured painting. It comes as no surprise that this work, shown in April 1913 at the exhibition of the Ontario Society of Artists, was judged by a three-man committee (one of whom was his former teacher Cruikshank) to be worthy of purchase by the Education Department of the government of Ontario. Today it hangs in the Art Gallery of Ontario. It looks dark and rough by comparison with later works by Thomson and the Group of Seven, but that it is on view in the same room is proof of its strength.

A Northern Lake was a marker on the path of the story of the formation of the Group of Seven. Thomson's interaction with the men who later founded the group was electrifying, not only for him but for them. Thomson's trip inspired them; that he had found such fresh motifs, and a new landscape, as a result of his travels provided an object lesson. They probably thought the trip looked like fun too. Soon, the group would begin to make more journeys. In time, their adventures would become part of the myth of the Group of Seven, and Thomson would become their explorer-hero.

1914: Formation of the Algonquin Park School

The inspiration travel can provide had taught a lesson to the group of artists who had looked so attentively at Thomson's sketches of 1912. Now trips become a common element of the developing story of the Group of Seven. At first, Thomson, was the instigator. He knew it was his mission to reveal the wonders of northern Ontario, and specifically Algonquin Park, to his friends. He chose the park over sites further north not only because it was the arena of Thomson family legend, but because the fishing was better. (Further north he caught pike; Algonquin Park had trout famous for their size and sweetness.) Also, he confided in a letter to a relative, he liked the people. He might have added that he liked the paintings that he did there which were so full of feeling for the country.

Arthur Lismer, an exciting painter full of ideas, joined Thomson in the park for a trip one spring, and once again Thomson's eyes were opened. What he learned from Lismer

Tom Thomson: Design for a Canadian Hero

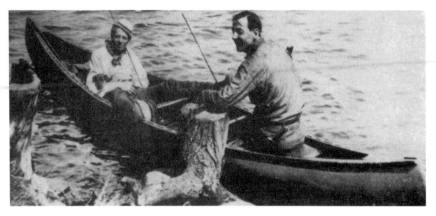

were new possibilities for motifs, and the special colour of the place. Lismer was tall, wiry, wind-blown, wonderfully volatile, enthusiastic, and a compelling speaker. He had been trained abroad and knew technically how to paint. Thomson must have been intrigued by him; he would have found him, like MacDonald, a delightful person to know, full of good design and art suggestions, and fun-loving. He incessantly drew quick, expressive cartoons: one showed Tom, pipe in mouth, sketching. Their time together was very droll.

The two friends went to Algonquin Park in May 1914, and camped on Molly's Island on Smoke Lake. They then travelled to Ragged, Crown, and Wolf lakes. In an account Lismer wrote immediately after the trip, he described the impact of the park on him. Some sections of it sound like quotations from Thomson, or what Dr. Brodie might have said on one of his tramps, which Thomson would have remembered when talking with Lismer. Surely, it was

Brodie who praised the park as a place where "the native animals ... live in security and wildness" as Lismer wrote later. Lismer's cry is one of delight, full of genuine pleasure at what he saw. He wrote:

We were there before the maple and birch burst into leaf and we stayed to see the wonderful miracle of a northern spring come again ... we stayed to see the woods carpeted with their infinite variety of colour, the little white Canada violet the sweetest scented of them all. Trilliums, Hepaticas, Jack-in-the-pulpit, Auriculas, Anenomes to name only a few. I wish I knew them all. They were a revelation to me of what nature in its wildest state can do [to] brighten up its sombre depths of shade.

As usual, Tom went out of his way to please him. "He's a man with a fine knowledge of the north," said

Lismer, and he added about the special qualities of the country:

> the north has an atmosphere and glamour all its own. I have never experienced anything like it anywhere else.... Imagine a glorious full moon coming over the tops of the spruce, big and yellow, shedding a mysterious light on everything.... [T]he moonlight had colour, you could see to paint and be able to appreciate the colour of things.

His first impression was profound, he realized, and charged with meaning.

Lismer's effect on Thomson was electric. Whatever Lismer praised, Tom painted. He used the colour purple-grey, mentioned by Lismer, for tree trunks, and explored in paint ideas about which Lismer had waxed poetic. He also delineated the trees of the opposite shore in the two stages Lismer had spoken of — the spruce silhouetted against the grey, purple, and browns of the top branches of the maples and birches. The technique he used showed Lismer's influence: he painted his sketches with blended colour, interwoven in places, in clearly defined strokes. Lismer had presented Thomson with a new form. As was Thomson's practice, he took it away and brought it back transformed. The result was a step forward in his work: the sketches he painted that year and his canvases that winter (for he had developed a pattern of "working up" his notes in Toronto) are fresher, bolder, and stronger.

The way Thomson and Lismer latched onto the idea of the north in their work was important to their acceptance as artists. Labels were easy; if someone was known as a commercial artist, the public was not going to be interested. Their use of northern imagery was an act of subtle aggression, a form of self-definition that got them off the commercial hook. Soon, with the encouragement of MacCallum, Thomson left his job

Arthur Lismer
Tom Thomson sketching in Algonquin Park, 1914
Photograph courtesy of Marjorie Lismer Bridges, Ashton, Maryland.

to paint full-time, to move into the Studio Building (as it was called) that was helpfully being built by Harris and MacCallum to provide a home for the new movement. The commercial artist had crossed over.

The next person to offer Thomson the benefit of his insight on a trip was MacCallum. Since 1913 he had watched Thomson's work grow in strength. In previous years, he had invited MacDonald and Jackson to his summer home on Georgian Bay, and now, in 1914, he invited Thomson. Like Lismer, MacCallum shared with Thomson his enthusiasms for the geography of the area, especially the peculiarly shaped islands that take the impact of a persistent wind, with curious identifying names like Seal Rock, the Giant's Tomb, the South West Wooded Pine (the latter a long, narrow island of granite). Thomson, ever the pleaser, painted a view of the doctor's cottage, as well as of places in front of, or part of, the island.

Then both men's ideas of what was worth making into art ran out — and so did Thomson's inspiration. He gave up painting for a few weeks. He wrote to Varley that he was disturbed by the social atmosphere of the cottage and the number of small children underfoot. The place was getting too much like North Rosedale (an upper middle-class suburb of Toronto), "all birthday cakes and water ice," he said, but perhaps he was just trying to please; after all, Varley and his wife hadn't been invited. One of the children on the island that summer recalled that, when she visited him in his small cabin, he gently nudged the chamber pot under the bed with his foot. He may have felt embarrassed. It was a feeling he must have hated; perhaps the incident helps explain why he left. Varley had told him to stick to camping, and he must have begun to think Varley was right. Now he invited the Varleys, the Lismers, and Jackson to camp with him in Algonquin Park. He knew they would help him discover new motifs.

The group arrived in Algonquin Park that fall. Jackson and Thomson arrived first, to be joined later by the Varleys and the Lismers. Varley's words in a letter to MacCallum convey the effect of the park. "The country is a revelation to me," he wrote, "and completely bowled me over at first." Though the weather was warm and sultry, the maples were already almost finished, their bright leaves having fallen. The birches, though, were still rich in colour. When Lismer arrived, there was enough colour for him to call it "glorious" in another letter to MacCallum. The warm weather was followed by heavy rain and big windy skies.

Together, they were inspired. Thomson, like his friends, began to apply brighter colour to his panels, and to use it in a special way, placing it over the surface in little touches so that the result was higher in key. Jackson spoke of his "cubistical" tendencies. "Tom is rapidly developing into a new cubist," wrote Varley.

The use of the word "Cubism" in the fall of 1914 in Canada would have meant, to these aware young painters,

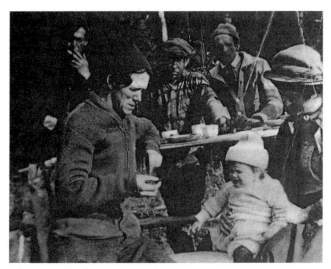

Algonquin Park, autumn, 1914.
From left to right: Tom, Frederick H. Varley, A.Y. Jackson, Arthur Lismer, Marjorie, and Mrs. Lismer.
Photograph courtesy of the McMichael Canadian Art Collection, Kleinburg.

Notice the way only Varley and Mrs. Lismer seem interested in the baby.

the avant garde in art. The word was in the air. In April of 1913 in the *New York Times*, a photograph had been reproduced of Marcel Duchamp, Jacques Villon, and Raymond Duchamp-Villon at home in their garden at Puteaux, France, with the heading "Brothers who Paint Those Queer Cubist Pictures." The caption read, "In the Photograph These Three Creators of 'Advanced Art' Seem Quite Normal...." In the *Detroit News* of February 28, 1914, the caption under a reproduction of the Cubist painting *The Wrestlers*, by Morton L. Schomberg, said "...Giddy Samples of the Work of Disciples of the Cubist Method of Expression."

The Canadians would also have heard about the paintings that Picasso began in 1906, and those of Braque in 1908, and perhaps even of Cézanne's letter to Émile Bernard, published in 1907, which contained the famous sentence: "You must see in nature the cylinder, the sphere, the cone." The impact would have been immediate. To them, Cubism would have meant something beyond Post-Impressionism; they may even have sensed that it referred to the reduction of the disorder of nature to fundamental geometric forms, the reduction and fragmentation of space initiated by Cézanne, and the use of vigorous brushstrokes to blur the transition between the picture planes.

By that fall in Algonquin Park, the influence of Cubism on Thomson appeared in the way he consistently used angular forms throughout his composition to unite trees and background, and in the reduction of spatial depth to a frieze-like relief parallel to the picture surface. He may have looked at Cézanne's paintings, albeit in reproduction, to learn how to reduce the shapes of his forms, and to fuse foreground and background by breaking the contour. Even his brushwork, with its short, parallel hatching strokes, recalls that of Cézanne, although only up to a point because Thomson was, in his heart, and in the way he explored colour in his work, more allied to Fauvism than the Cubists in France. His breakthrough was that, through the influence of his friends, and especially of Jackson, he realized he could rearrange

the design and composition of nature as he had his work in the engraving trade. The knowledge proved to be liberating.

Jackson said that, in his work of this season, Thomson was transposing, eliminating, designing, experimenting, finding "happy colour motifs amid tangle and confusion, revelling in paint." The key word is transposing; that is, creating a synthesis of design. The idea that he could, like God, transform nature — so different from simply copying what was before him — helped his personal vision come into play, and stimulated his ideas of design, light and dark pattern, coherent pictorial structure, and rhythmic continuity. He must have joked to himself that he was a rock of the new movement — or at least that on the rock of Algonquin Park, the new group would build its church

— for on the sketch *The Brook*, he selected a boulder as the place to sign his name.

That Thomson continued to rely on others for the education of his eye is a clue to another quality of his personality; we have seen the trait in action before. Blessed with the ability to pick out every detail of what he saw, he needed people around him to qualify that experience. His urgently felt need for his artist friends, expressed in many letters written to them from the park asking when they would visit, is proof of the persistence of his desire for a community of artists ("I should like awfully well to have some company," he wrote in 1915). A group acts as a support mechanism. What this group shared included not only ideas but frames, stretchers, even food. In the winter of 1914–15, Thomson shared his Toronto studio in the

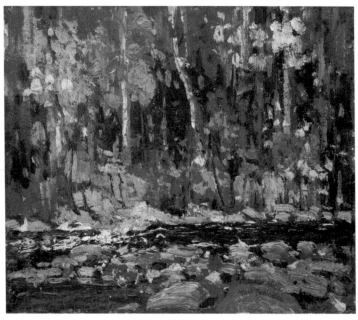

The Brook, 1914
Oil on canvas, mounted on brown wood-pulp board, 22.4 x 27.0 cm
National Gallery of Canada, Ottawa.
Gift of Dr. J.M. MacCallum, Toronto, 1944.
Photograph courtesy of Joan Murray Tom Thomson Papers.

Studio Building with Carmichael, who described this early co-operative in Canadian art to his fiancé, Ada: "Everyone is doing their best to do something for the mutual benefit of the other fellow." It showed the "true spirit of comradeship," he wrote. The group that had developed shared some qualities of the Thomson family, especially their open-handed ways.

Thomson must have spent much of his time worrying about finding material for the next sketch, and the one after that. He also worried about his life and finances. But there was yet another matter that added substantially to his burden of worry: on July 27, 1914, war was declared between Austria and Serbia. By September, Canada was sending men overseas. The very idea of what the men were going to would have horrified Thomson's sensitive soul. Anxiety, hysteria, panic: these are the condition of the artist, and they were part of Thomson's psyche. Like any pleaser, he was reluctant to voice his distress, probably thinking it was too repetitive and commonplace for him to mention. Nor did the ability he showed of grasping structure very quickly, and following with distilled, simple images, seem to be the creative method of a person who is swallowing down panic. But the way he needed friends around him to keep on being a painter is proof of immense stress. In Toronto, working in the Studio Building with companions solved the problem for awhile. It would re-emerge, particularly when he had to face a threat to his existence as an artist: marriage.

Photograph of the Studio Building, Severn St., Toronto, 1938.
Photograph courtesy of Dr. Naomi Jackson Groves, Ottawa.

Today, one of the places where Tom painted in Toronto, the shack that used to be next to the Studio Building in the Rosedale ravine, has been moved (slightly fixed up) to the McMichael Canadian Art Collection in Kleinburg, Ontario.

6

Philosophy of Art: 1915–1916

As we know, Thomson was raised in an enthusiastically cultured family, among people who liked to read, sing, and play music. For his own reading, he preferred poetry, he told one of his aunts. As a youth, he owned a book of tales by Chaucer — *The Prioress's Tale and Other Tales,* translated into modern English by Professor Skeat and published in 1904. Another example of Thomson's interest in poetry was noted by A.Y. Jackson in 1914. On his fall trip to Algonquin Park, Jackson noticed Thomson reading all night on the veranda of Mowat Lodge, the hotel where they stayed before they set up camp. Jackson recalled that the book was poetry. He also remembered that Thomson recited "The Wreck of the Hesperus," a long ballad by Longfellow, a standard elocution exercise of the day but one that was proof of his powers of retention.

When he was in Toronto, Thomson followed recent developments in poetry on Sunday-morning visits to homes of friends such as Dr. Albert Durant Watson. It was

during such visits that, sometime between 1912 and 1916, he heard about "the finer things of life" in a discussion group of a dozen people. The talk was often of poetry; the poets most discussed were Bliss Carman and Charles G.D. Roberts. Carman may even have read his poetry to this thrilled crowd. Though Thomson may not have been lucky enough to hear him, we can still imagine that he would have been interested in the desire of Carman and Roberts to create a national school in literature. Their poetry examines nature realistically while rejoicing in its mystery and beauty — themes Thomson would have found sympathetic. Such poets would have seemed to him harbingers of a new age, the age to which he knew he belonged.

He had already been introduced to philosophy by his family and Brodie. Now Carman's mystical and transcendental thought must have struck a chord. We know that he read Maurice Maeterlinck, the mystical Belgian playwright, whose transcendental platform included the belief in the oneness of the individual with the absolute. Thomson's quotation from him, in a decorative penwork illustration, must be one of his most prosaic lines: "It is well to have visions of a better life than that of every day, but it is the life of every day from which elements of a better life must come." Yet Thomson was likely intrigued by Maeterlinck's transcendental thought, and by the same quality in Carman. Thomson's paintings have semi-

religious overtones, as viewers have often noticed: often in his work the viewer looks out from some secret place. The quiet mood the forms impose in Northern River, for instance, and the silhouetted shafts through which the well-lit central place is viewed, are reminiscent of the inside of a church. Thomson, like Carman and MacDonald, and many in the nineteenth century, deified Nature. He would also have been sympathetic to the "Cult of the Open Road" that Carman voiced in his Songs of Vagabondia. From an early date, he had wanted to travel.

Yet it is not Carman's poetry that had the deepest affinity with Thomson's work, but that of another poet, little known today, William Wilfred Campbell (1861–1918). There were special reasons why Campbell would have been so appealing to Thomson. He was probably born in Kitchener, Ontario, but he grew up in Wiarton, near Owen Sound. Unlike Thomson, he attended Owen Sound High School and he frequently returned on visits. Thomson, or his family, might have seen or met him; they surely knew of his work. In the titles of some of his paintings, Thomson may have specifically quoted fragments from Campbell, and Campbell may have been the source of some of his themes. Campbell's collected Poems, which contained all that "the author cares to preserve," appeared in Toronto in 1905. In its introduction, the poet spoke of the nature of poetry. It was,

a sort of instrument which thrills the soul not only by what it reveals but what it suggests. For this reason, a mere esthetic word-picture, no matter how carefully wrought, is not in the true sense poetry.... It may emulate the careful photograph, which seemingly loses nothing yet fails to catch the one necessary insight which the painter who is a genius puts into his picture — that light that never was on sea or land, yet which all men see sometime or other in what the average world may call the dull and commonplace.

Such sentiments would have struck home to Thomson, who was later to make powerful works of sites that would not, previously, have been considered subjects suitable for art. Moreover, in 1912, Thomson did a sketch that he called *Sky (The Light That Never Was)*, of the rare hazy early-morning light of Algonquin Park: he could have been thinking of the passage quoted above — Campbell's idea of what constituted genius. Other striking parallels exist between the words of the poet and the work of the painter. Campbell entitled a poem "A Northern River," one of the subjects Thomson painted early in 1915. The rousing poem, supposedly the voice of the river itself, may have provided Thomson with a title and perhaps even a source of inspiration, since a northern subject was what he wanted to convey.

Using such poetry as a source of inspiration was part of Thomson's desire to ennoble what he found in nature. "Lift it up, bring it out," he said to park warden Mark Robinson, describing the process through which he made art. These words referred to what he intended in his art, as well as to the way he liked to isolate and develop motifs from his sketches. He desired to create a symbol of the woods. Thus he might use trees he had seen on an island in Georgian Bay but, as in *Pine Island, Georgian Bay*, he purified and strengthened the trajectory of their trunks and branches to reflect some pattern from the fashionable international style of Art Nouveau. Inevitably, he mentally took a step backwards to deal with his subjects. He added foreground space to his canvases so that the image from the sketch was set off in depth. The trees, too, are better defined, simplified, with less foliage than those of the sketches. Such evidence we have of his paintings during this period, including their rich, heavily worked, and built-up surfaces, is that the process of creation was lengthy and laborious.

Thomson's creative method was one of experimentation: for him there was no final answer. His mind was full of ideas of the beauty of harmonious colour schemes; of the subtle charm of landscape, often under the shadowy effects of evening; of what he read in magazines; of the latest art abroad. He studied and tested styles such as the Austrian Jugendstil, which he appropriated for murals he created for the walls of

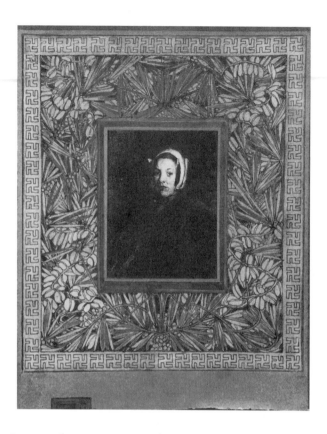

Design for a painting by A. Curtis Williamson
(1867–1944), 1914.
Pen and watercolour on paper, 27.9 x 22.9 cm
Private collection, Toronto.
Photograph courtesy of Joan Murray Tom Thomson Papers.

*One of Thomson's heroes in design was William Morris, and he
particularly admired his illustrations for his book* News from
Nowhere *(1890). Thomson shows the influence of Morris in the
ornamental border he painted to frame the work of a fellow artist in the
Studio Building.*

Dr. MacCallum's cottage. He might have been interested in the way illustrators such as Jessie M. King from the Glasgow School of Art, who showed her work at the Art Museum of Toronto in 1912, inked their elaborate illustrations. One of the greatest designers of them all, William Morris, who designed for the Kelmscott Press, was another inspiration — especially the elaborate, rich pages of his *News from Nowhere* (1890). In one design, Thomson painted a central watercolour, possibly based on one of his Algonquin Park panels, and set it into a rectangular frame inspired by Morris. Possibly Thomson had heard of Kandinsky too — perhaps from MacDonald, Lawren Harris, or Eric Brown, the director of the National Gallery of Art, who went camping in Algonquin Park about 1915, was friendly with the group, and perhaps knew Thomson (they may have met when Thomson lived for a short while in Ottawa about 1915). For some, Thomson's flower studies may seem to use an idea favoured by Kandinsky early in his career, especially in his flower subjects, of painting up from black in the background to lighter colour or even white, but the idea was common to designers of the early years of the century — for instance, Oskar Kokoschka used a black background inset with coloured flowers in his lithograph *Flower Garden* (1906–08). Thomson's quotations from such sources are difficult to determine since they were never slavish: they merely indicate the sureness of his taste.

His quotations from poetry have a similar lightness of touch. Thus, it was perhaps the general nature of Campbell's verse that influenced him, with its odes to the sunset, studies of wind, and numerous reveries on autumn colour or winter snow, more than specific poems. It seems distinctly possible that Thomson, like Campbell, wanted to dwell upon the human, and nature as affecting the human, rather than upon objective nature as solely an esthetic experience. For example, Thomson's *Autumn's Garland* delineates and evokes much the same image and mood as Campbell's "Autumn," which spoke directly to the

> Spirit of Autumn, siren of all the year
> Who dost my soul with glamouries entwine;
> As some old trunk, deep in the forest drear,
> Is gloried by some crimson, clinging vine...

The rich cadence and evocative power of the words were probably a matter upon which Thomson meditated in private, and which he would have translated into a painting. Being reticent, he would not have spoken of such ideas to friends. Yet one of them to whom he could have spoken with absolute freedom was Harris.

This handsome, charismatic painter, trained in Berlin, the child of a sophisticated, wealthy family, didn't mind speaking his thoughts. As their friendship deepened in 1915 and 1916, he would have told

Thomson how he had been introduced to unorthodox religious matters, as he would have described them, in his student days in Berlin. In 1914, Roy Mitchell, director of the theatre at Hart House at the University of Toronto, had introduced Harris to Theosophy, and took him as a guest to a meeting of the Toronto Theosophic Society. It was probably around this time that Harris began to read more deeply the work of Ralph Waldo Emerson (to whose work he had been introduced in Germany), as well as authors such as W.B. Yeats, Plato, P.D. Ouspensky, Madame Blavatsky (as he became more involved with Theosophy) and religious works such as the Upanishads. We may be backdating what we know was to later become a matter of profound concern to Harris, but there is one curious detail that seems to indicate that an exchange took place between the two painters. After Harris lent Thomson art books from his large library, Thomson's sister Margaret asked Thomson which books he had borrowed. He replied, in a half-joking way, "only the best." His words need not have referred only to the high quality of books in Harris's library; perhaps he also meant books about the "finer things."

He would also have taken a close look at Harris's paintings, which reduced the shapes of landscape to essentials. Harris typically placed bold complementary colours side by side with white space in between so that the colours vibrated, a style, as Harris would have told him, drawn from an artist he admired, the Swiss

painter Giovanni Segantini. The American painter Marsden Hartley had been influenced by this work too, and showed "Segantini-stitch" (for this was what the technique was called) paintings in New York at Stieglitz's important 291 Gallery in 1909. It was a show that Harris might well have seen.

We can be surer of Thomson's thought if we look at his work. He rarely valued his sketches as art; what counted for him were the set pieces, the canvases he developed in the studio. They crystallized his thought, he would have said. For instance, in his sketches he might paint a series of trees on the shore — still, blown by the wind, or even as dead stumps — but only in the great canvases such as *The West Wind* and *The Jack Pine* do we feel that he has evoked a nature poet such as Shelley, who formed an important part of his reading. In his paintings, as in Shelley's "Ode to the West Wind," the forest is a great cosmic force.

The West Wind is an example of the way Thomson would have drawn on poetic imagery. Behind the two trees firmly set upon the shore, we see the "steep sky's commotion" of which Shelley wrote. One tree is bent to a bow like the frame of a harp or a lyre — and Shelley had begged the wind to make of him "its lyre, even as the forest is." Yet it might not have been Shelley alone of whom Thomson thought, but also Wilfred Campbell. Campbell had written a poem, much influenced by Shelley, that he titled "The Lyre of the Gods." Several of its lines seem to evoke Thomson's

painting, especially "There is a lyre whereon the mad winds play / The sad old songs of dead gone yesterday." Campbell mentioned in the poem all his heroes of poetry and verse. In this modern time, he added, only the lonely wanderer touches the tree's dead strings, or the sonorous, sad winds of autumn. Thomson's painting is an autumn subject, so possibly he had Campbell in mind.

Likely, too, he thought of an author whose prose-paintings of nature it would have been very natural for him to read, coming from a Scottish family, and whose ideas he might have discussed with Lismer: John Ruskin. As a student, learning to draw, he had read Ruskin's *The Elements of Drawing*. Now he might have dipped into, and enjoyed, *Modern Painters* and *The Stones of Venice*; he would have understood them as a unique blend of science and imagination, and perhaps regarded them as models of what he sought to combine in his own art. Ruskin's interest in botany and geology led him to an allegorical view of nature, rather in the manner of the medieval bestiary: the vine he saw as a symbol of waywardness, and the pine, its complement, as an emblem of steadfastness, since it refuses to bend with the wind. These two images especially come to mind when we look at Thomson's work in the winter of 1916–1917, for in that season he painted several pine subjects as well as *Autumn's Garland*, a painting of a woodland vine. If we are correct in our reading of his personality, these subjects would have

68

signified to him opposite ends of the spectrum of human character.

What he must have felt he needed to examine in greater depth was the nature of the changes that took place through the passage of time — hence his need to be present in the park to paint. His choice of a stage-set like space in his paintings reflects something of the drama in which he felt he was acting. The other actors in the play were the members of the new group that was forming.

Acting: the idea may help to explain the frenzied way with which he sought subjects. Mark Robinson recalled how Thomson would come to him "on a run" to inquire, breathlessly, "Where is it?", then describe the motif he needed. Thomson was playing a part.

The incident Robinson recounted should be examined with care because it reveals other features of Thomson's life and working habits. One time he told it, it went as follows:

> We saw Tom come almost at a run over the Joe Lake Portage. Canoe over his head. Throwing his canoe into the water he seized his paddle and shooting the canoe out into the water paddled like a mad man to our wharf, here he pulled up his canoe in haste and up into our cabin. Say Mark you know. I know you know just what I want, three trees. Spruce trees. Black spruce rough cold looking trees you know what I mean. Trees against a cold green grey northern sky where can I get them at once. I said Tom just tell me what you want and possibly I can help you. He then described the three Black Spruce trees, I said go to the little wharf below Sims Pit. You will find those trees you want in a group, but can I get them again [sic] a cold northern sky I assured him that I thought he could. he [sic] was away like a shot and like a wild man was disappearing over the portage. Three days later Tom came in to our cabin. there was a big smile on his face, as he said, say Mark, those trees where [sic] just what I required for my canvas, and the sky just right. How do you always know what I want. I could only tell him Tom you describe the things so accurately its no trouble to remember the odd things we see ever [sic] day.

Robinson wrote the account quoted above in a letter to Thomson's first biographer, Blodwen Davies. Another time, to a reporter, he told the story of how Tom came into the house, "his hair straggling down over his eyes; his shirt open; buttons off in various places." In this version, Tom, on his return, said to Robinson, "It was the right mood, it was just what I was looking for." Robinson used the incident to point out that Thomson was more than a realistic painter. Thomson conceived the composition first in his mind,

then sought what he wanted in nature, he said. Robinson said that "he wouldn't put in a tree if it wasn't there, nor would he take any out." "Other artists," he said, "sometimes criticized him for the colours he used, but he would say that he painted nature only as he saw it."

MacCallum apparently used to ask Tom "if he could really tell me he ever saw anything like that," but then bought the work. To the end of his days, he saw Thomson's sketches as providing an archival record of Algonquin Park; for this reason he left his collection to the National Gallery of Canada in Ottawa. Yet, we should realize that Thomson's words were highly stylized. He took them from a book we know he read and enjoyed, Rudyard Kipling's *The Light That Failed* (1903), since he quoted from it in a decorative pen sketch. In it, the artist-hero says that many will complain about the brilliant and unusual colours he has used, but "these were the colours I saw." Thomson appropriated the hero's words for his own.

As Robinson suggests, Thomson's art was highly selective. Art itself is a filtering device. He knew what he wanted to paint, and discovered it, using the eye of a trained designer. He imposed patterns on nature, with the aim of creating good design.

We still can consider him a naturalist painter. Bill Quinney, in a scholarly paper prepared for a course on Canadian landscape art given by Dennis Reid, the University of Toronto professor and curator at the Art

Gallery of Ontario, uses this term to describe Thomson. Thomson's beliefs and ideals, Quinney says, are reminiscent of nineteenth-century naturalistic artistic and literary tendencies. He traces the influence of science from the time of Charles Darwin, and discusses how such ideas prompted a new vision of the world. He believes that Thomson, introduced to the naturalist's viewpoint by Brodie, sought to transcribe his impression of the natural world into art. Quinney points to Courbet as an example of an artist who similarly wished to transfer the scientist's point of view into art.

Naturalism is a recent term in art history, enunciated by art historian Gabriel Weisberg in his *Beyond Impressionism: The Naturalist Impulse* (1992). Weisberg describes the style as beginning about 1870 in England and America, and reaching its apogee in Paris in 1889. The aim of the naturalist artist was to record truthfully the variety of nature, though Weisberg relates the impulse to figural work: modern-day history lessons, he calls this category of painting. Quinney would say that Thomson objectively recorded landscape in his sketches; his canvases are something different.

Our immediate response to Thomson's sketches is to the natural elements: the way Thomson has suggested the placement of trees, foliage, the colour of the sky. But then his art takes over — his brisk but delicate handling of paint, use of colour, and

powerfully summarized form, all creating the drama and design of his art. Probably the truth about Thomson is that he had a naturalist's intention but a Post-Impressionist technique, if by the latter we refer to his painterly effects — and thus he was both at once. Jackson had told him about the various techniques he learned in France such as undercoating and glazing, as well as about Impressionism, Pointillism, and Seurat, describing to him how to create clean-cut dots of colour. Jackson felt Thomson's style changed under his influence. That Thomson did experiment with Jackson's ideas is clear from his work, particularly his Petawawa sketches of 1916 — which show large turquoise and orange dots — and canvases of that year such as *The Pointers*. In that season, he extended his points of reference in other ways, too, even perhaps using the basic idea of simplifying his sketches so that some of them pushed at the edge of representation. He must have eliminated certain features of the scene before him, and strengthened others. In some sketches, trees rest flat against the imaginary edge of a picture plane; the frame acts as a way of cropping nature. He blocked out colour in flat areas placed adjacent to one another like so many tiles on a roof. It's as though he were building a surface, not just recording. Perhaps in 1916 he felt less like making careful nature studies, more like making rough colour notes. Perhaps that is why, in the spring of 1917, he turned so carefully back to representation, recording

the change in the seasons. "I've got to make a more careful record," he may have said to himself.

Why his art began to diverge from representation or naturalism may be traced to an upsetting event in the life of the new group. He had, as we know, been inspired by the presence and friendship of MacDonald, Varley, Lismer, and Jackson. Now, in the autumn of 1915, Jackson left to join the 60th Battalion Infantry to fight in France. His departure brought the Great War home to Thomson in a new way.

Thomson's own involvement in the war has long been a matter of conjecture. A sister wrote that he had tried to sign up but was turned down, either because of the damage done by his early illness or a physical disability — flat feet. He may have planned to try to sign up again later. Meanwhile, he would have added the war to his list of worries. Maud Varley recalled that Thomson stood with her in Toronto to watch a parade of men on their way overseas. Thomson was truly upset over what the men were going to, she recalled. In 1946, William Colgate, an early writer on Canadian art, suggested that what upset Thomson about the war was not fear of death, but the spiritual menace, "the mutilation of the mind," which could wound far beyond any physical hurt.

The war had an immediate impact on his work. Like his anger, it served to sharpen his artist's insight. It also had an effect on his finances. With the outbreak of war in the summer of 1914, the attention of the

public was completely diverted. All artistic effort and patronage of the arts ceased. Because railway and steamship companies became the transport vehicles for troops and munitions, orders for tourist publicity, folders and advertisements, the mainstay of the commercial houses where Thomson and his colleagues worked, were cancelled — and the staff laid off. Artists had to enlist or seek new jobs.

From Algonquin Park, where he had gone to work as a fire warden, Thomson wrote MacDonald that his comfortable tranquillity was in contrast to "the wild clamour of the world in arms." His words hid the depth of his feelings.

Since his youth he had been an avid reader of Rudyard Kipling, one of the most patriotic and imperialist authors. (At Christmas time, 1905, he had given his parents a copy of the writer's *Barrack Room Ballads*.) And since Thomson was of Scots descent, he had strong ties with Britain. When he thought about the war, his reaction must have been similar to the feelings of other Canadians.

Sandra Gwyn in *Tapestry of War* says that reaction to the war established the pattern for society for roughly the next half century. She quotes from the public servant, Brooke Claxton. The questions he asked were "Why is he dead? And why, when he is dead, do I remain alive? Why?" These are the ultimate questions of those who survive tragedies; those who ask them, Gwyn says, consciously try to answer them by

developing the kind of Canadian institutions and Canadian spirit that "would serve as memorials to those who had fallen in foreign fields." Thomson was surely one of those who questioned, and who found an answer in his work.

He may have found part of his answer in the last lines of the poem by Shelley, about which we have already spoken, "Ode to the West Wind." It reads "O Wind, / If Winter comes, can Spring be far behind?" Thomson's subjects in 1915 often seem to echo that sentiment; they are paintings of regeneration — of life after death in nature. Spring follows winter, wild cherry trees blossom, the land that was burnt over bursts with bloom. Even the waterfalls and rapids suggest a bursting vitality and energy. Life! these sketches seem to cry; that was what he was about; recording life in all its vigour.

He was a changed man, more certain of himself, full of confidence. His friends noticed. MacCallum spoke of the sureness of brush strokes in his sketches of 1915. By now, Thomson was at home with the four basics of art: colour, tone, drawing, and composition. To this he would have added subject matter, which he had now brought under his control.

What remained for him to work on was technique.

One experiment in the fall of 1915 suggests that he was trying to discover a new path: a single semi-abstracted sketch. Strongly related to other outdoor paintings of the fall season, it irons out the dot

notation and heavily worked surface of some of those panels into a smooth, flat pattern. It is a précis from nature: a work that dispenses with detail. Behind it lies the wood interior he often painted. He could not have known that this, and the work he painted in the fall of 1916, often on the back of more finished sketches, would be developed in depth by later painters in Canada, ignorant of his work. But he might have sensed that such a thing could happen. After all, he was Tom Thomson.

Blazing the Trail: 1916

7

"Pleasers" are by nature gregarious. Without an audience they have no one to please, so they always try to surround themselves with people from whom they can take direction. Thomson had made the moves necessary to form such a group — from selecting members to choosing an appropriate subject matter. Now it was time to trail-blaze a style. His instinct was to be distinctly modern, and even, by the standards of the day, avant garde. To decide how such a style should look, he studied the work of a number of his contemporaries.

Thomson had long relied on Jackson's technical guidance: Jackson had made three trips to study in France. During the second one, from 1907 to 1909, he enrolled at the Académie Julian to study with Jean-Paul Laurens. "Jean Pol," as Jackson liked to call him later, taught him to paint form like a glove from which the hand had been withdrawn; that is, as though it were three-dimensional. While on that trip, Jackson learned more than

75

academic technique; he learned about Impressionism and Pointillism. On a third trip, he visited places in France such as Cucq, as well as going to Italy, to Assisi and Venice. He would have showed Thomson several sketches he had painted in Venice. Abroad, he also picked up books on the latest movements in art. These he shared with Thomson when they worked together in the Studio Building in 1914, telling him about the work of Pissarro, Sisley, and Monet, as well as of the men themselves, whom Jackson implied he knew — at least by reputation. Thomson was quick to seize upon the new technique for his own work. Jackson had shown him how to work his brushes in little strokes, like Monet or Seurat, and he tried the effect first in sketches, then in his canvases. Jackson would have spoken to Thomson of complementary colour, of bolder paint handling, of flattening the picture plane. Now, in Algonquin Park in the spring of 1916, he thought of Jackson again. Perhaps books he had borrowed from Harris had reminded him of what Jackson had said about using "clean cut dots of colour, not colour all messed up," or perhaps he thought of Jackson in what he called the "Great Machine," the war overseas, and wanted to send him a picture postcard. The feathery dots Thomson applied to the sky of the sketch titled *March*, the dots for the water in *Northern Lake, Spring*, and the dots for both sky and water of *Islands, Canoe Lake*, applied in strokes of pink, cream, turquoise, and lavender, are evidence of his eagerness

to experiment with what he had learned.

In another group of sketches he painted that spring, Thomson studied the logging industry in the park, working with images from log jams, timber chutes, and even the lumber camp at night under a starry sky. He also focused on two Canadian inventions: the flat-bottomed red boats known as pointers because of their undercut bows; and the scow-like craft known as the alligator, which was equipped with winch and cable to haul logs and break up log jams.

That spring and fall he also studied a subject to which he'd already given much thought. "Pine Country," he'd written on the back of one sketch; the simple description economically describes the lake, hills, and sky of Algonquin Park.

Then, in the studio that winter, he received a visit from painter Florence McGillivray. Although she is almost forgotten now, at the time she was a formidable presence. The visit of this older woman had considerable meaning for him: he was to store her calling card and an invitation to her show of 1917 in his paint box, where they were found after his death. He even told Mark Robinson how much it pleased him to have her call on him. "Quite confidentially," he said, "she is one of the best."

Born in Whitby, Ontario (like Thomson's father) this strong-willed woman's background paralleled Thomson's in many ways. The McGillivray family "came out" from Peterhead in Scotland at the same

time as Elizabeth Brodie, Thomson's grandmother, and they were intimate friends with her. McGillivray's grandfather was the naturalist and bird painter Charles Fothergill, and as a girl she had gravitated towards a career in art. Enrolled at the Central Ontario School of Art and Design and the Toronto Art School, she had, like Thomson, studied with Cruikshank, among others. Unlike Thomson, she then had the good fortune to continue her study abroad. In 1913, she went to Paris to work at the Académie de la Grande Chaumière. That year, she progressed enough to exhibit a painting of a French nun, titled *Contentment*, at the Salon des Beaux-Arts. In the same year, she was elected president of the International Art Union, a group that was dissolved when the war started. In the following year she travelled to Brittany, where she may have heard about Gauguin and the School of Pont-Aven, then to Venice, where she, like Jackson, painted.

What she could have encouraged in Thomson was an increase in the boldness of his paint handling. She herself used the palette knife, masses of colour, and a strong black line around forms, no doubt as a result of influence from the School of Pont-Aven — or the work of Ferdinand Hodler, which she may have seen when in Paris. (One of his portraits in the Musée d'Orsay, *Madame Godé Darel Malade* [1914], has the same heavily worked handling as her paintings.)

Thomson told others that he valued her advice. "She was the only one who understood immediately

what I was trying to do," he said. Like her, he wished to experiment in his art, to forge an independent style.

There were other artists from whom he borrowed ideas that winter. One was Lawren Harris. From him, he took the square format canvas, and perhaps even the idea of using very broad strokes of colour. Later, on viewing works of this season, MacCallum spoke of Harris's "patent" sky.

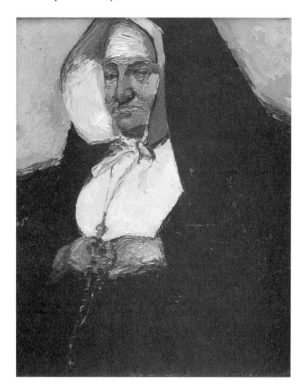

Florence McGillivray (1864–1938)
Contentment
Oil on cardboard, 41.0 x 32.7 cm
Art Gallery of Ontario, Toronto.
Gift of F.H. McGillivray, 1936.

When Thomson combined these ideas, one result was *The Pointers*. In this painting he applied the Pointillist technique, which he had experimented with that spring and fall, in his logging and "pine country" subjects. It was probably MacCallum who titled the painting *The Pageant of the North*; the brilliant colours of water, sky, the three pointers pulling a cadge crib, and the way the boats progress across the picture plane, give a festive air to the autumn scene. The colourful panorama of trees in the fall in Algonquin Park is developed through dabs of blue, orange, pink, yellow, and green on an orange-brown ground. White strokes delineate trees; the rapidly flowing water has short brush strokes of blue, green, yellow, orange, pink, and yellow. It was Thomson's answer, using a strictly Canadian subject, to the challenge posed by European painting, and perhaps especially by Canaletto's spectacular painted tributes to the Festival of the Doge in Venice. In some of those paintings, the old Venetian state barge, called the Bucentaur, accompanied by gondolas, proceeds in a stately naval parade across the picture plane. The colours of the boats and costumes are predominantly red and gold, a forceful contrast with the sparkling blue waves and sky. Thomson could have seen such works in reproduction in library books, or perhaps in a book in Harris's extensive library. Perhaps he mentally compared the pointers to gondolas; the Canadian boats could be viewed, with poetic licence, as the gondolas of the north. It is a charming thought, worthy of an artist destined to please a much larger audience than a mere group of friends.

Thomson's avant-garde technique and intention are equally clear in *The Jack Pine* and *The West Wind*. In terms of colour he was guided by MacDonald's enthusiasm for the work of Vincent van Gogh. The Dutch painter had used complementary colours such as red and green to bold effect, drawing upon the work of the chemist Michel-Eugène Chevreul (1786–1889), whose study of optics had proven so important to the Gobelins tapestry factory in France.

The basis of Chevreul's observations was a physiological fact about the eye, as Ralph E. Shikes and Paula Harper observed in their book on Pissarro's life and work. They wrote that:

If one looks for a minute or so at a square of intense red and then at a white wall, one will see a "ghost" afterimage — a square of greenish hue, green being the complementary (or most highly contrasting) colour to red in pigment. The same phenomenon occurs with the other complementary colours of pigment: blue/orange, yellow/violet, etc. If a stroke of pure red is placed next to a stroke of pure green in a painting, both the red and the green will appear more brilliant, since the green afterimage the eye produces from the red

makes the green appear greener and the red afterimage produced by the green intensifies the sensation of the red. The relationship between the two colours produces an effect (in interaction with the eye of the viewer) which does not exist if the two colours are separated and looked at singly.

Thomson had undoubtedly come across such complex interactions of colour already in commercial art. He would have been well aware that the complement of green is red, though unlike Pissarro, he concluded that to avoid chemical mixing of two different hues, he would apply one as an undercoat, then, when it was dry, the other. In two canvases of trees that would later prove significant to Canadian art, *The West Wind* and *The Jack Pine*, he seized on the optical idea and left spaces around the branches so that, as the red shows through, it seems to vibrate. The effect is visually dynamic. He added to it by outlining and enlivening the tree foliage with blue paint.

In other canvases he painted that winter, the composition is often that of a flat surface screen through which the viewer's eye is led to a distant background. At the centre is nature framed by foliage. For instance, in *Evening, Early Spring*, we look through branches towards a far shore; in *Maple Saplings, October*, we look through the branches of a twisted sapling at the centre of the composition; in *Autumn's Garland*, we look through the garland to the background. The pattern is repeated in a way that seems obsessive, to say the least, in the work of an artist who was a trained designer. It occurs so often that we should ponder what he intended, or what he might unconsciously have had in mind.

The focal point, we notice, is round or oval in shape, rather like an almond placed on end. The form is one of which mystics, such as St. Theresa, speak when they describe the light and fire that surrounded their bodies in the moment of religious ecstasy. Looking again at *The West Wind* and *The Jack Pine*, we realize that they have a hallucinatory quality. We may wonder if he intended them as mystical visions.

Thomson, in an early pen sample, chose to quote from Maeterlinck a line about "visions" of a better life. On first reading it, the reader might presume that he referred here to "better" in the sense of more valuable possessions, or knowledge of "the finer things." Could Thomson have meant more than that, or something entirely different? Could the key word have been "visions"?

W.H. Auden wrote, in an introduction to *The Protestant Mystics* (1964), that most people have had first-hand religious experiences of one kind or another. Mystical experiences, whether concerned with God or with his creatures, he says, have, of all experiences, the most right to be called first-hand. He suggests that there are four distinct kinds of mystical experience:

1. The Vision of Dame Kind, a "given" experience, not induced by will, but sometimes by chemical means, such as alcohol;

2. The Vision of Eros, which seems to the subject not only more important than anything he experiences in a normal state, but also a revelation of reality;

3. The Vision of Agape, seeing the visible world and its creatures with extraordinary vividness;

4. The Vision of God, a vision more common to children and adolescents for whom religious beliefs play a part.

Thomson's vision, if it occurred, might have been the first described by Auden, the "Vision of Dame Kind." The basic experience, as Auden describes it, is an overwhelming conviction that the objects confronting the visionary have a numinous significance and importance, that the existence of everything he is aware of is holy. The basic emotion is one of innocent joy. Auden said that those who have this vision desire nothing except to continue in communion with what Gerard Manley Hopkins called the inscape of things. This is the vision of the natural mystic, Auden said, and, though the fact may be irrelevant, he pointed out that most accounts of this kind of experience have been written by people with a Protestant upbringing. In the Mediterranean countries the individual

experience of nature as sacred is "absorbed and transformed into a social experience, expressed by the institutional cults, so common around the Mediterranean, of the local Madonna and the local saint." As for the person who experiences it, there is nothing to prevent him from welcoming such a vision as a gift, however indirect, from God.

We know, from Thomson's past history, of his love of nature: it is possible to wonder if he could have had a vision at this time. Or possibly, had he had one earlier, even as a boy, when he roamed the woods at home? Did he try to express it now because of Harris's influence — or did it come to the fore because of the war? In the repeated use of a composition in which nature seems to surround the viewer, and in the hallucinatory effect of some of his canvases of 1916, he seems to have been trying to express something that had a profound effect on him — something transcendent and extraordinary.

A vision of the splendour of creation, Auden postulates, lays a duty upon one who has been fortunate enough to receive it, "a duty in his turn to create works which are as worthy of what he has seen as his feeble capacities will permit." That winter there were more hints which pointed to a specific new thought in Thomson's work. They stemmed from a new source, one he had long admired, the stained-glass windows of the American artist Louis Comfort Tiffany.

In Tiffany's landscape windows the composition is

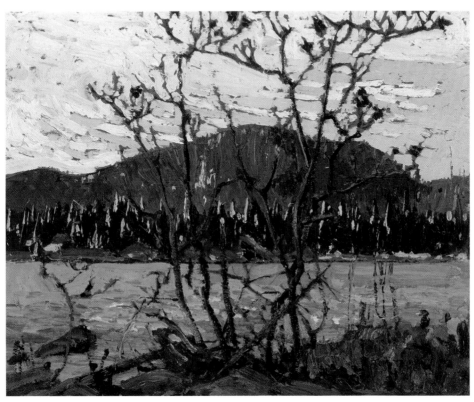

Northern Lake, Spring, c. 1916
Oil on panel, 21.4 x 26.5 cm
Private Collection.
Michel Filion Photographe
Photograph courtesy of Galerie Walter Klinkhoff

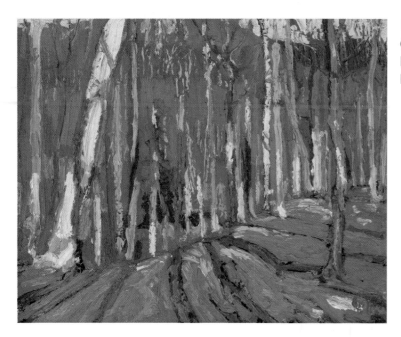

Wood Interior, Algonquin Park, 1916
Oil on panel, 21.1 x 26.5 cm
Private collection, Ottawa
Photograph courtesy Michel Filion Photographe

Snow in the Woods, c. 1916
Oil on panel, 21.9 x 27.0 cm
McMichael Canadian Art Collection,
Kleinburg
Purchase with funds donated by
R.A. Laidlaw
Photograph courtesy of Joan Murray Tom
Thomson Papers

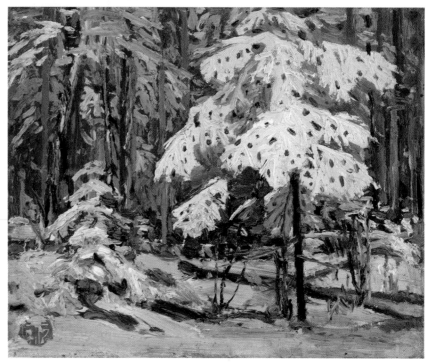

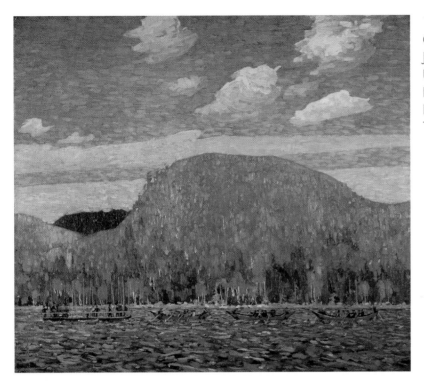

The Pointers, c. 1916–1917
Oil on canvas, 102.2 x 115.6 cm
Justina M. Barnicke Gallery, Hart House,
University of Toronto
Purchase, 1928–1929
Photograph courtesy of Joan Murray Tom
Thomson Papers

Maple Saplings, October,
c. 1916–1917
Oil on canvas, 89.5 x 99.7 cm
Private collection, Toronto
Photograph courtesy of Joan Murray
Tom Thomson Papers

Autumn's Garland, c. 1916–1917
Oil on canvas, 122.5 x 132.2 cm
National Gallery of Canada, Ottawa
Purchase, 1918
Photograph courtesy of National Gallery of Canada, Ottawa

Decoration: Autumn Landscape, c. 1916–1917
Oil on canvas, 31.1 x 113.0 cm
Private collection, Toronto
Photograph courtesy of Joan Murray Tom Thomson Papers

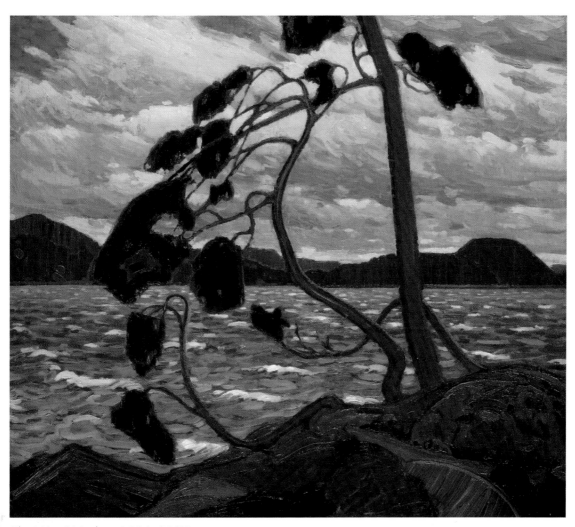

The West Wind, c. 1916–1917
Oil on canvas, 120.7 x 137.5 cm
Art Gallery of Ontario, Toronto
Gift of the Canadian Club of Toronto, 1926
Photograph courtesy of the Art Gallery of Ontario, Toronto

The Jack Pine, c. 1916–1917
Oil on canvas, 127.9 x 139.8 cm
National Gallery of Canada, Ottawa
Purchase, 1918
Photograph courtesy of National Gallery
of Canada, Ottawa

Autumn, Algonquin Park, c. 1916–1917
Oil on canvas, 51.2 x 41.0 cm
McMichael Canadian Art Collection, Kleinburg
Gift of C.F. Wood, 1975
Photograph courtesy of Joan Murray Tom Thomson Papers

Twilight, c. 1916
Oil on panel, 21.3 x 27.0 cm
The Weir Foundation, Queenston, Ontario
Photograph courtesy of Joan Murray Tom
Thomson Papers

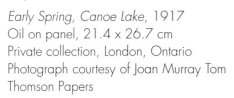

Early Spring, Canoe Lake, 1917
Oil on panel, 21.4 x 26.7 cm
Private collection, London, Ontario
Photograph courtesy of Joan Murray Tom
Thomson Papers

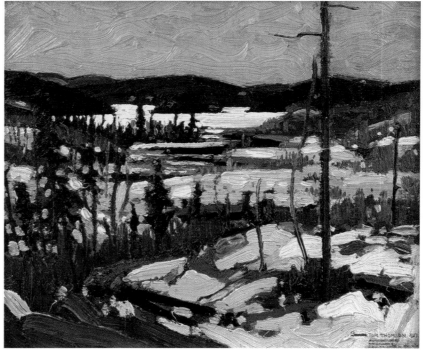

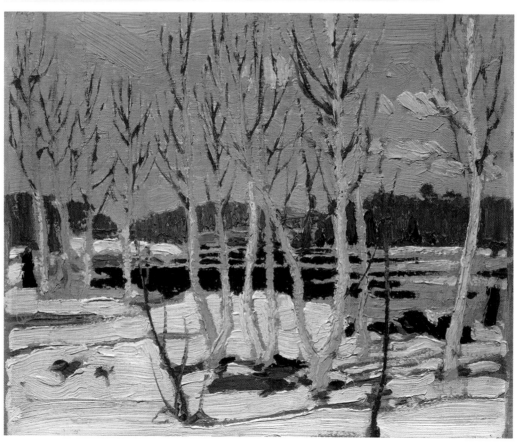

April in Algonquin Park, 1917
Oil on panel, 21.3 x 26.7 cm
Tom Thomson Memorial Art Gallery, Owen Sound
Gift of George Thomson, 1967
Photograph courtesy of Joan Murray Tom Thomson Papers

often one of a central focal point in a distant background to which the eye is progressively led, in a series of steps from foreground to background. It is an academic way of working, and one that he had, like Thomson, acquired from a multitude of sources (including Old Masters such as Botticelli, and popular French and American salon painters of the day). Yet his windows created a totally new impression when the old-fashioned composition was combined with the theme of nature, and the rich, luminescent colour of his stained glass.

Thomson, perhaps under the influence of a desire to specially express something that had happened to him, reached out to the work of Tiffany, America's greatest contributor to the Art Nouveau style. It would have mattered to him that many of Tiffany's stained-glass windows were ecclesiastical commissions, and more than that, that the American had successfully combined a religious function with the use of emphatic curvilinear forms modelled on those found in nature. What Thomson developed from Tiffany was not a copy. In the same way he had developed from his earliest work as a designer, he simply used the composition as a springboard for his imagination. However, he wanted us to know that stained glass was his source. In his canvases of this season, he left revealing traces of its presence in the luminescent, "chunk-of-glass" handling of his sky and water.

There is a trace of still another source: Claude Monet's painting *Cap d'Antibes* (1888). Here Monet used as his motif a tree that crosses the canvas in a stunning, fluid diagonal to form a dramatic contrast with the sea and sky. There are differences in technique: Monet animated the field through small calligraphic strokes to create a mosaic or tapestry-like surface of colour, while Thomson used larger and bolder areas of colour to create a pulsing, powerful design. The two paintings spell out the difference between Impressionism and Post-Impressionism. Monet's tree extended from left to right, in a direction opposite to that of Thomson's trees in *The West Wind*, but for a master designer it would have been the work of a moment to reverse the design. The parallel between the two is a close one. Thomson may have felt that he was painting a Canadian answer to the challenge offered by French painting, as he had in *The Pointers*. Unlike some American and French artists, he was driven to advocate modernity, and had contemplated simplifying his work strongly in paintings of the previous years. For him, the stylistic innovations of the Post-Impressionists of the 1890s came almost as commands, so the translation of Tiffany into his work would have been a way of conveying a delicate religious sentiment that underlined the popular nineteenth century aphorism in which he and his friends so much believed, "God is Nature."

With this idea in mind, we can look again at the sketches of Thomson's last spring, and consider them

to be the raw material for a possible grand new plan he was developing. Perhaps the subject he planned to paint in his canvases the following winter would have been the old European idea of the four seasons — but with an appropriately Canadian subject matter.

W.H. Auden concluded his analysis of the "Vision of Dame Kind" by suggesting that it has been the initial cause of all genuine works of art, and of all genuine scientific inquiry and discovery, "for it is the wonder which is, as Plato said, the beginning of every kind of philosophy." What we sense, glimmering at the heart of Thomson's work of the winter of 1916, is the beginning of such a philosophy. That it involved Canada is important: he meant to create a Canadian tradition, distinct from American and European ones. The idea that we have of our culture, based on our landscape, and later to be explored in depth by the Group of Seven, was embraced in his work at this early moment, only six months before he died, in 1917.

Did he tell anyone else of his "vision"? Possibly he did. After Thomson's death, MacDonald wrote an inscription for his cairn in Algonquin Park. In it he said that the wild had "revealed" itself wonderfully to Tom, and spoke of "revelations." If Thomson spoke personally to anyone, it would have been to his friend, Mr. MacDonald, and MacDonald might have wanted to indicate what he had heard.

8

Algonquin Spring: The Diary of 1917

The last spring of Thomson's life provides a touching coda to the gathering intensity of his artistic life, so soon to be cut short. We have already noted his habit of visiting Mark Robinson, his recollections of Dr. Brodie, and his passion for nature. One day during that summer of 1917, as so often before, Thomson dashed into Robinson's cabin with a question: Could he hang in the cabin his "records," as he called them? These were the works he had painted that spring and summer, a canvas a day for sixty-two days, he said, showing the stages of the advancing season. He wanted to leave them on Robinson's walls for the summer. The warden said that he could.

Thomson wanted to see them all together, since hanging them would show him if his series worked. Seeing them in one place might even help him find his way to what he might paint in the future. Until now he had worked in the traditional way, from the sketch done in nature to the canvas developed in the studio back in Toronto. A series was a

new idea for him — and an important one. His use of the word "records" was also important. He meant the word in its dictionary sense: he felt he had created documents of the scene before him. He felt that his oil sketches would allow interested observers, in later years, to see how Algonquin Park looked through the passage of a season. He saw his work as evidence, a literal document, not only of nature, but also of his own daily experience within that nature. He was, in addition, using "records" in the Impressionist sense, as notations of perception, light, and climatic change. Monet's series were much on his mind from his reading, as was Jackson, who was still in Europe, a soldier artist in the Great War.

There may have been another idea in Thomson's mind when he called his work "records," and it lay in his memory of Dr. Brodie's suggestion that he keep a journal. Now Thomson took up the idea to express his inward landscape and his personal way of seeing, which sought to strengthen the design of nature. Though his reference point might have been Brodie and his extensive biological records, for Thomson records meant paintings. They made an assertion about external reality — the weather, time and place, the species of trees — as well as serving to reflect his state of mind, and even his emotion in the landscape. The external landscape reflected his inner state; he sought harmony with nature, wonder before its mutability. He readily would have agreed that his records weren't

photographs. Still, they freshly conveyed the course of the seasons from spring to summer. What he saw was important: it was his appreciative diary of a place he loved, and where he felt at home.

Sadly, Thomson never had a chance to clarify exactly what his series meant to him. Nor did he ever get to see the sketches in one place. His death, within weeks of his conversation with Robinson, remains a Canadian cultural tragedy. The friends who later formed the Group of Seven knew immediately that they had been deprived of a genius. Future generations came to see his death as a matter of almost personal loss.

The sketches themselves were scattered. From Mowat Lodge, the hotel on Canoe Lake where Thomson sometimes lodged, Thomson's brother took them to their father's home in Owen Sound. "Tom's brothers and sisters got most of them," Mark Robinson recalled later; though curiously, after his death, only

Mowat Lodge, Canoe Lake, Algonquin Park, 1917.
Photograph courtesy of Harry Ebbs, Toronto.

about forty of them remained. No doubt he had pruned some, and scraped and reused others, as he seems to have done with one sketch of northern lights. Some he destroyed. Charles F. Plewman, who was at Mowat Lodge when Thomson died, remembered that, following the creek one day, he found sketches that Tom had broken up and thrown away.

To reconstruct the work Thomson painted that spring and summer is not easy, but we have one useful clue: most of them do not have the Tom Thomson estate stamp, a small palette with the initials "TT" and "1917" devised by his friends as a mark of authenticity and used on the sketches he left in his studio in Toronto. There is also the characteristic size of some of the work of this season. Thomson's chronic lack of money that year had affected his choice of materials. He had given up his park warden's job, and though he planned to work as a guide (he had acquired a guide's licence in April), he seems to have earned only a few dollars. As a result, he was sometimes short of painting supplies, so occasionally he used the backs of oil sketches as a sort of notebook, drawing trees or birds on them and adding colour notes. To this season I also date a number of 11.8 x 17.2 cm panels of wood that seem to have come from the crates for Gold Medal Purity Flour and possibly California oranges: fragments of these product names appear on the backs, as on *Birches* and *An Ice Covered Lake*. I was also helped in dating sketches

of this season by the notes of MacCallum and other friends such as Jackson, who jotted dates on the backs of works.

The series, as Thomson told Robinson, showed the progress of the spring and summer. He had arrived at the end of March to find snow on the ground and ice on the lakes. Slowly the snow melted, revealing growing patches of mud, and then the ice broke up and the creeks began flowing. The weather varied. It was mostly cold and wet, but in April and May Thomson wrote to MacCallum that the weather had been warm. The sketches he painted on these mild days were few, since often in good weather he worked at odd jobs for local residents, putting in vegetable gardens or helping with construction. In the sketches we see mostly scenes of wintry to spring-like skies and partially frozen lakes. The land still looks sombre and cold; the days were grey. A day or so before his death, Thomson wrote, "the weather has been wet and cold all spring."

On the back of one sketch painted this season, *Tea Lake Dam*, MacCallum recorded that it was of "a thundercloud at the chute." He noted that "the rush of the water and the feeling of daylight is very marked as well as the feeling of spring." He went on to record that "in the trees or bushes in foreground on right side of creek I found a poachers bag with Beaverskins + c [et cetera] — sketched Just before his drowning [*sic*]." On the back of the sketch are three drawings of a bird. MacCallum may have recorded the note so carefully

because some people had said Thomson's death had been caused by poachers. MacCallum may have wanted to provide evidence that poachers were in the park when he was there.

For some, Thomson's sketches of this spring seem repetitive, and had he lived, no doubt he would have scraped off and reused more of the boards. Many of the works I've dated 1917 are sky studies, with simple, wedge-like indications of land. I include in this group his magical and luminous sketches of the northern lights, mostly because friends such as Robinson recalled he painted them this spring. Other informants who were in Algonquin Park at the time, including Mrs. Daphne Crombie, helped me to identify which of the northern lights sketches these might be. In another group, depicting the spring breakup, Thomson recorded the rapids and the way the water flowed over the rocks or flowed past the bank where he may have sat as he painted. *Swift Water* is the appropriate title of one of these: the waters are dark and dynamic, full of splashes and eddies. Thomson also painted the birches by the water, their forms disposed like musical notes in a score, or crossing each other like dancers on a stage. The patterns interlock, at ease with each other, in intricate counterpoint like music made visible. What Thomson perceived in the woods was a space crossed by verticals, often with several diagonals for variety. The result is never claustrophobic; always a touch of sky or lake opens up the view. Thomson disposed his

trees with an unassuming, almost playful charm, but at the same time a sense of authority.

He makes us aware of the snow as it melts. On April 21, in a letter to MacCallum, he recorded that the snow was "pretty well cleared off." Patches on the north sides of the hills and in the swamps were all that remained, he said, so now he had to hunt for places to sketch when he wanted snow.

Within these silent spaces he recorded, Thomson found that the snow (about which he wrote to his father on April 16) interested him more than anything. He meant the drama of the winter season, played out in a setting of trees, branches, bushes, and land, where light and shadow offer boundaries to the stage set. In his day, Kipling's romantic description of Canada as the "Lady of the Snows" was widely quoted, but Thomson's attitude towards snow was based partly on aesthetic, and based partly on his friendship with Harris. Harris loved in snow its whiteness, and found in it an image of purity that fit well with his growing interest in theosophy. Thomson would have been sympathetic to Harris's point of view, but would add a love of colour to the mix of ideas about snow. By reflecting light, snow offers rich and changing possibilities of hue, like a prism. It also provides a textured surface. When painting snow, Thomson usually slathered on paint like creamy icing. His heavy paint build-ups offered some relief in a sparse formal repertoire consisting of tree trunks and

thinly brushed branches or bushes. *Winter in the Woods* (the title of a sketch of this season) is one of his great subjects.

Yet if he thought of Harris and silently spoke to him through his work, we know something else about Thomson: he was lonely. A drama cries out for an audience. Thomson wanted companionship, often writing to friends to ask when they would visit. Dr. MacCallum did come, as we know from his note on the back of a sketch; and Thomson painted *Tea Lake Dam*, one of his finest sketches, on a trip with the doctor, as though to show him what he could do. Another visitor was Harris, who was thrilled by what he saw in Thomson's work. Later he recalled the sketches of this season as the finest of Thomson's life.

As we look at them we realize that the landscape, its moods, and the times of day and year had become part of Tom's imagination. The sketches he painted resonate with a feeling for the authentic shape of the country of Algonquin Park. The subjects he chose demonstrate that he went to the earth to reclaim a kinship. In the way of a true guide, who is not only knowledgeable and wise but eloquent, these sketches keenly evoke an unusual place. They have a crispness, a brevity, and most of all, an intense focus; their quality suggests that through them, Thomson was gearing up to say more, to attempt more. After all, he was the artist who in the previous winter had painted *The Jack Pine*. Works like this had given him confidence. Now his painting hand

had acquired new lightness. He commonly dragged paint lightly to give the merest indication of branches, trees, or splashes of water. And he let the surface of the wooden board show through; he let the material work for him. He was in his element, painting at his best. His hour had come. Even the use of a series, the idea of art as a process with an inevitable succession, shows us that Thomson had begun to think more of the future — his future.

There are other signs in his work that these sketches were expected to take him somewhere. In several brilliantly conceived works he chose to see the view from a height. The result is a panorama, unusual in his work. Where was he going? What was he reaching for?

No doubt he was trying to put the place in perspective. To do that, he disengaged himself from it, and standing back a little in order to see it clearly and as a whole. Keeping a diary of day-by-day work was an expression of the same impulse. Perhaps he wanted to record the park because he thought of leaving it and painting elsewhere, possibly in the Rockies, as he told a brother-in-law; or perhaps he thought of marrying, which probably would have meant disruption and another sort of leaving. He was seeking to find himself. Perhaps in the process he remembered Dr. Brodie, the man whose teaching had coloured his whole existence. After years of being at sea over what he was to do with his life, he had developed a sense of purpose. It made him realize why he was on earth.

Death and Resurrection: *1917*

9

On July 8, 1917, Thomson set off in his canoe to fish near Canoe Lake. His body was found over a week later. The coroner's report, now lost, returned a verdict of accidental drowning, though it noted a four-inch bruise on the right temple and an earbleed. Speculation that Thomson's death was not a simple accident has never stopped. The question of how he died has become a staple of writers, amateur sleuths, and serious scholars. There are two books that deal with the subject: William T. Little's *The Tom Thomson Mystery* (1970) and a novel by Roy MacGregor, *Shorelines* (1980). Joyce Wieland's film, *The Far Shore* (1976), deals with the suspected murder of a Thomson-like hero. Later writers who knew the people of Algonquin Park thought Thomson might have been killed by an American he apparently hated. An article in 1977 in *The Toronto Star* by MacGregor suggests that Thomson was murdered, and that the murderer's wife told the story to friends.

This version of Thomson's death draws upon an interview by an Algonquin Park warden with Daphne Crombie, who knew Thomson. She had heard the story from Annie Fraser when she returned to the park from Toronto in November 1917, expecting to stay all winter, as J. Shannon Fraser wrote Dr. MacCallum. One of her first questions to her friend Annie must have been "What happened to Thomson?" Annie Fraser's answer was that he was killed at night by her husband, Shannon, during a drinking bout. The two men had quarrelled over money Thomson had lent Fraser: he had paid for two canoes, worth $250, for Fraser, and though some of the money had been repaid, there was still a large amount owing. Thomson wanted the money to buy a new suit, Annie told her. This detail rings true, since Thomson at the time did not own much in the way of clothes. His vanity may have been specially piqued at this particular moment in his life because he had been written by Winifred Trainor, his girlfriend, to buy a suit in which to get married, and he seems to have intended to marry her. Likely, her words hurt his feelings. In the fight between Thomson and Fraser, the story goes, Thomson fell, and hit his head on a grate (hence the bruise on his temple), and was knocked unconscious. Fraser, terrified at the thought that he'd

killed Thomson, woke his wife; together they tied Thomson's feet with fishing line, packed his body in a canoe, paddled into the lake, and dropped the body in. They then returned to the lodge and set his canoe adrift. "It was nothing but that fight they had and Shannon's fist," said Crombie.

Crombie was upset by Fraser's story, and when she returned to Toronto, went to MacCallum. When she told him her suspicions, he didn't seem to be listening. He spoke of the sale of a painting to the government for $500 (presumably *The Jack Pine*.)

How can we evaluate Crombie's story? Such

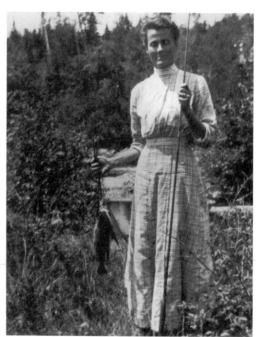

Photograph of Winifred Trainor.
Photograph courtesy of the Tom Thomson Memorial Art Gallery, Owen Sound.

evidence as we have is conflicting and perplexing. The lost coroner's report pointed out that Fraser was the last man to see Thomson alive; he saw him about noon, Fraser said. Mark Robinson thought he saw Fraser and Thomson together in a canoe the morning after the party, though at some distance.

From the evidence of a much later interview, Crombie qualified her own words. "This is my conception," she said at one point. And yet the role of Shannon Fraser after Thomson's disappearance was extremely active, perhaps suspiciously so. When cottagers on the lake saw Thomson's empty canoe floating in the water, it was Fraser who wanted the warden to drag for the body. It was Fraser who sent a telegram, then a letter, to MacCallum the second day Thomson was missing. Then, when the body was found, he sent a telegram saying, "Found Tom this morning." To Thomson's father he wrote to explain the death was an accident: "The Dr. found a bruise over his eye and thinks he fell and was hurt and this is how the accident happened." It was Fraser who spread gossip that Thomson had committed suicide after having contemplated the act for some time. Thomson, he said, was depressed at the thought of marriage to his girlfriend. Trainor was coming to see Thomson to have a showdown, and Thomson felt he could not settle down.

Fraser's stories seem close to the story his wife told Crombie: Fraser was the last to see Thomson alive,

Thomson fell and was hurt — it was an accident. The rumour of an impending marriage to Trainor, and Thomson's feeling of panic, may also have been true. The pleaser was faced with a dilemma: he could only escape by displeasing, and he wanted out.

Nevertheless, Fraser's insinuation that Thomson didn't want to marry Trainor made her so angry she went to Thomson's family. She wrote his father that Thomson hadn't liked Fraser as he "hadn't a good principle." Thomson's brother-in-law, T.J. Harkness, echoing her, said Fraser was "ignorant and without principle." He wrote to ask if Fraser's debt to Thomson had been repaid, only to receive an injured letter from him, though handwritten by his wife, assuring him that no money was owing. Fraser was devious, said Mrs. Crombie, and mercenary: he tried to sell Thomson's shoes after his death. In 1928, he offered three Thomson sketches to Hart House at the University of Toronto for $125 each. (It bought two.) The remaining one, of Thomson's canoe, went to the Art Gallery of Toronto later.

Crombie was ever after convinced that Fraser had killed Thomson. He had a violent temper and people in the park were afraid of him. She believed Annie Fraser had told her the truth. Annie was decent and honourable, said Crombie. "She never told me lies, ever." All I can add is that, when I interviewed Crombie about Thomson's work in 1971, she was a careful witness. She did not seek notoriety for her version of

Thomson's death. Indeed, she did not mention one word about it, though, of course, as a serious art scholar, I did not ask.

If Crombie's story is true, Thomson's death was less murder than manslaughter — an accidental death caused by violence. Why wasn't there any fuss? A.Y. Jackson wrote: "It was not till years later when he had been acclaimed a genius that strange tales were told about his having been the victim of foul play." At the time, only a few knew the circumstances of his death; most were baffled. Newspapers said that his body was missing, then that it was found. He had drowned. People spoke of his having been murdered by poachers: as a park warden he'd been known to have fierce arguments.

MacCallum, perhaps due to his aloof nature, or to a desire to leave Thomson's name unsullied, apparently kept Crombie's suspicions to himself. Nor did Thomson's friends discuss his death in public. There was a further poignant dimension to what one must regard as a predictable reaction of the day; they disliked the thought of what, in time, they may have come to feel was a misadventure. It was as if death by violence — as opposed to death from clearly natural causes — somehow lacked dignity, was tinged with a delinquency that lessened the man's character.

Whatever the reason, his friends seem to have been disinclined to speculate about his death. Likely they investigated for themselves, discovered that it had been an accident, and resolved not to speak of it, since they must have felt his death had nothing to do with his art, and, after all, nothing could bring him back.

Anyone acquainted with Thomson's violent mood fluctuations can only wonder at the reactions of his friends to his death. His powerful individualism may have been another side of a depressive personality. Yet it seems his fellow artists did not know his dark side; certainly they have not recorded it, and it appears only in the records of youthful companions and the apprentice at one of his early jobs. Even if misadventure was not in his later friends' thoughts, the senselessness of the death certainly was. None of them could speak out frankly; they were bound by what became a taboo subject. No doubt this contributed to the sense of a close-knit band, and played its part in the founding of the Group of Seven. In this creation, Thomson's genius and early death became the defining myth. The members of the Group of Seven were largely responsible for preparing the ground for Thomson's reputation with the public. Fighting for his art was a way of fighting for their own ideals.

The key figure was Jackson. In 1917 he was in England as a war artist, waiting to go to France. On the news of Thomson's death, he wrote MacDonald to say that in all the turmoil around him it was shocking "that the peace and quietness of the north country should be the scene of such a tragedy…. It seems like the ruining of another tie which bound me to Canada."

Then Jackson launched into his often-quoted words about Thomson: "because without Tom the north country seems a desolation of bush and rock.... My debt to him is almost that of a new world, the north country, and a truer artist's vision." This letter is crucial to our understanding of the Thomson myth. Facing the insanity of world war, Jackson yearned for wholeness. Thomson, who had lived in artistic isolation in Algonquin Park, suddenly took on, in Jackson's eyes, a primitive splendour.

The north, too, had a special resonance for Canadians sickened by the war in Europe and its homicidal madness; more than before, the north now seemed the soul of their country. Jackson spoke of it as a treasure trove of new motifs, a perfect place for the boys' adventure club which the early Group of Seven became.

IO

In Memoriam

By September 1917, J.W. Beatty and other friends raised a cairn to Thomson on a prominent point of Canoe Lake in Algonquin Park. MacDonald, both poet and lettering man, wrote and designed the inscription:

He lived humbly but passionately with the wild.... It drew him apart and revealed itself wonderfully to him. It sent him out from the woods only to show these revelations through his art, and it took him to itself at last.

Those words made Thomson a kind of woodland god, and suggested the myth-making process that was beginning. The "quest" was seen as a sort of communion with the spirit of the north. A more pedestrian, but still glorified Thomson appeared in MacDonald's article, "A Landmark of Canadian Art," in the November 1917 issue of *The Rebel*.

Describing the building of the cairn, MacDonald spoke of Thomson's "concentration of purpose, and his natural genius and knowledge, and sympathy with his subject."

The same fall, Thomson's old friend and patron, Dr. MacCallum, busied himself with the sale of Thomson's paintings. He wanted to further the work of someone he considered a great painter, to assist as he had during Thomson's lifetime. He was thinking of a special collection at the National Gallery of Canada in Ottawa, as well as a memorial exhibition. The exhibit was held in December at the Arts and Letters Club in Toronto. George Thomson, Tom's brother, wrote Dr. MacCallum to suggest that the doctor would be the appropriate person to title the larger paintings. In the meantime, MacDonald had asked their usual framer, Charles Boughton, for a price on frames. As a dated note in a sketchbook shows, MacDonald ordered one hundred frames for Thomson's small sketches at thirty-five cents each. He also framed two canvases: *Morning*, and one he called *Ice (Red Shores)*.

By 1918, the process of elevating Thomson was fully under way. C.W. Jefferys, in that year's Annual Report of the Ontario Society of Artists, said that the group "was the means of introducing Thompson's [sic] work to public attention, and desires to record its regret at the untimely ending." In the same year in *Canadian Magazine* MacCallum wrote of Thomson, "He lived his own life, did his work in his own way, and died in the land of his dearest visions." His colour, said MacCallum, "sings the triumphant Hosannas of the joy and exaltation of nature." He drew a picture of Thomson in nature: "Puffing slowly at his pipe, he watched the smoke of his camp-fire slowly curling up amongst the pines, through which peeped here and there a star." This vision of Thomson was to prove significant to later artists, and to the public.

In 1919, his work was exhibited at the Arts Club of Montreal. Jackson, more plain-spoken than MacDonald, wrote the pamphlet essay. Thomson, he recalled, was equally happy when he "caught a big trout, when his bannock turned out well, or when he brought back a gorgeous sketch; [he was] a poet, a philosopher and a good friend." In 1920 there was a large show of Thomson's work at the Art Gallery of Toronto. The anonymously written catalogue essay, awash with mysticism, expanded the myth: "Alone by his camp fire, the moon a silvery green pathway on the waters, the stars peeping through the solemn pines, he communed with the Spirit of the North, and straightaway was freed from the shackles of the town." The inscription on the cairn was reproduced in the catalogue as well.

In the 1920s, Thomson's paintings became a standard part of major exhibitions. *The West Wind* travelled to Buffalo in 1921, to London in 1924, and to Paris in 1927, where it was shown in an exhibition of Canadian art at the Musée du Jeu de Paume. The

foreign press reacted favourably to Thomson's work, even suggesting what it felt to be the influences that shaped him. In 1924 the Glasgow *Herald*, for instance, noted that the patterning of *The West Wind* was in the "Japanese tradition" — a questionable assertion.

Plans were also made to place major paintings in public collections. On an estate list, possibly from 1917, there is a record that Sir Edmund Walker, founder of the Art Gallery of Toronto, declared that "the museum will buy one painting ... [and I] will buy two for the National Gallery." However, Walker's promise was not kept until nine years later, when Thomson's friends and family almost had to force *The West Wind* on the institution.

In the years immediately following Thomson's death, the family began to set modest prices on his work. George Thomson suggested thirty dollars for his brother's sketches, though he added that the price would be lowered in the case of the purchase of a group of works. In 1918 the National Gallery of Canada bought twenty-five sketches at twenty-five dollars each. Dr. MacCallum was asked to help fix the prices of the larger canvases and to consult with one or two artists, such as MacDonald, who were most familiar with Thomson's work. Sales were few. In 1921, when the Toronto Gallery still had not shown an interest in purchasing a work, Jackson suggested that *The West Wind* go to the National Gallery. The following year he suggested that the family price the

canvas at seven hundred. or eight hundred dollars. Probably because of his advice, by 1923 the family had decided on $1,500.

Throughout this period, Jackson and MacCallum vigorously prodded the trustees of the Art Gallery of Toronto to make them realize, as Jackson said, "that they should have one of the most important of Tom's canvases." In a letter of 1922, Jackson, in an apparent change of heart, wrote that, since the gallery was being reorganized and a Canadian room was promised: "the first picture we want in it is *The West Wind*." Eric Brown, the director of the National Gallery, had wanted it, he wrote, but he now believed it should go to Toronto, since all "Tom's associations in art were round Toronto," and the group wanted "Thomson with them." The gallery's funds were low, however, and usually spent on European art. *The West Wind* was finally bought for the gallery by the Canadian Club of Toronto in 1926, through the persuasive help of Dr. Harold Tovell of Toronto, influenced by MacCallum and Jackson.

Thomson's friends did all they could to enhance the fame of the painting. In 1924 Frederick H. Varley could tell a gifted student, Robert Ross, that Thomson was already a legend. Several of the group used their writing talents to good effect to perpetuate the Thomson myth. F.B. Housser, in *A Canadian Art Movement*, called *The West Wind* "northern nature poetry ... which could not have been created anywhere else in

the world but in Canada." But as MacCallum wrote in a 1930 letter, "Housser never knew poor Thomson — never even saw him." The myth had taken hold to such an extent that by 1930 MacCallum felt compelled to stake his personal claim to its creation: "You will find in an old *Canadian Magazine* about 1918 or 1919 an article on Thomson by me — it has been the source from which all the articles about him have been drawn," he wrote a friend.

Artists who had never known Thomson joined in the blossoming celebration of his genius. There was something rich about his work, something modern, that combined high art and moral seriousness about Canada. From Fred Haines, principal of the Ontario College of Art after J.E.H. MacDonald (and owner of two Thomson sketches), to Pegi Nicol MacLeod, who in a wintry sketch evoked Thomson's trees or a rocky shoreline in the 1930s, or W. P. Weston, who in his 1934 *Whytecliffe* painted a tree on the edge of a cliff, later artists found in Thomson's work a seemingly inexhaustible source of motifs. Now Thomson seemed to belong to an idyllic picture of the north, to classic Canadian culture; and the place he loved, Algonquin Park, to the tradition of an enclosed garden (albeit a wild one), a stronghold in the face of the encroachment of foreign influence (mostly the United States).

Much later, in the 1970s, Thomson was claimed again for the cause of nature and the north. In part, this was the result of a leading strain of Thomson

criticism produced by a generation of art teachers and students: what we might call the lyric landscape party line. It was also due to writers such as myself and Harold Town, who saw Thomson as an exciting painter whose abstract and painterly qualities were as crucial as his subjects. By the early 1980s, his work again seemed to fit the dominant political agenda in art: abstraction was on its way out and representation on its way back. Under the auspices of Postmodernism, earlier ideals of art were reinstated (radically this time), and earlier culture re-examined, even back to the time of its emergence. In Canada, artists thought of Thomson.

In autobiographical comments, they re-imagined Thomson, not as a precursor of the Group of Seven, but as a Canadian innocent driven by obsessive concerns. Usually his sketches were preferred to his major canvases — they were intuitive, passionate, energetic, and vibrant — whereas, following a convention we often find in art history, the larger works were said to be influenced by suggestions from other artists, and over-designed, picky, overpainted, and dead. Best of all was Thomson's life "in nature."

Painters such as David Alexander of Saskatoon, or Lorne Wagman in the Owen Sound area, claim to spend as much time in nature as possible; they model their work on Thomson's sort of nature experience. Alex Cameron of Toronto consciously followed Thomson's example to make sketches in nature (though his are in watercolour) which he uses as the

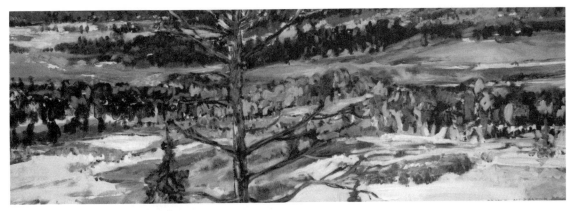

David Alexander (b. 1947)
Stretch, 1988
Acrylic on canvas, 43.5 x 125.0 cm
Robert McLaughlin Gallery, Oshawa.
Gift of Joan and W. Ross Murray, Whitby, Ontario.
Photograph courtesy of the Robert McLaughlin Gallery, Oshawa
(T.E. Moore, Toronto).

basis for paintings. He values the way Thomson used paint as though it were the material of a drapery before him. Looking into a sketch is like looking into a box, he says, and points out that when the sketch is projected as a slide, it is flattened so that it looks like a colour field painting. He loves not only Thomson's Canadianness, but the low eye-level view he used to paint his sketches: the scenes done sitting in a canoe convey a readable image to all Canadians, he believes. Today, we are outsiders when we look at nature, Cameron observes; the special quality of Thomson's work is that it helps us regain a feeling of purity in the face of the outdoors.

Richard Gorman also thinks of Thomson's work as a model as he paints in his Toronto studio memories of the Limerick Lake area near Bancroft, west of Ottawa, and of the Ottawa River, often at dawn or when rich colour is in the sky.

Rae Johnson sees in Thomson an artist who came to grips with northern light. In paintings of her pond in Flesherton, Ontario, near Owen Sound, and of the country in North Bay and elsewhere, she studies natural light and reflection, "the way the sky envelopes you," she said. Thomson shrank the horizon to focus on the sky, she believes; so does she. She lives in the north, and is affected by Thomson's example; the natural world has become a grounding device for all her work. She corrects what she feels is his mistake by keeping the scale of her brushwork in the medium of the small sketch the same as in a large painting. For

99

Joyce Wieland (1931–1998)
Tom Thomson and the Goddess, 1991
Mixed media on paper, 28.0 x 38.1 cm
Robert McLaughlin Gallery, Oshawa.
Photograph courtesy the Robert McLaughlin
Gallery, Oshawa.

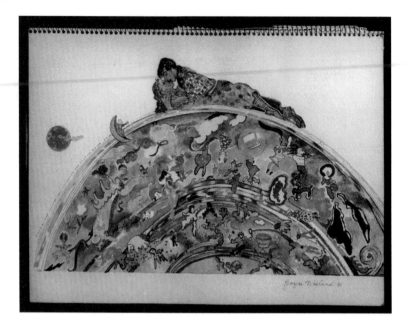

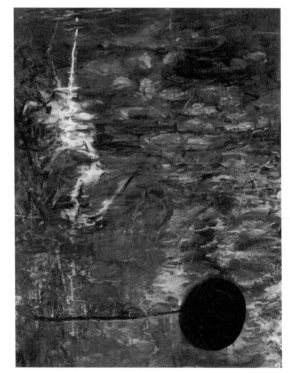

Gordon Rayner (b. 1935)
Evidence II (Concerning a Drowning in Canoe Lake), 1989
Acrylic and felt hat on canvas, 160.9 x 125.7 x 10.5 cm
Robert McLaughlin Gallery, Oshawa.
Photograph courtesy of the Robert McLaughlin Gallery, Oshawa.

her, his real subject is the continual observation of the forces of nature, and hence the passage of time: therefore he qualifies as a Postmodern thinker, up to date with today. But most important, he legitimized working in nature, she says; he was the first to make it all right for a nation of people who grew up close to nature to be who we are.

Joyce Wieland and John Boyle, by contrast, used the Tom Thomson legend to underscore their consuming interest in myth. Wieland presented Thomson as the artist hero in her film *The Far Shore*, then in her later watercolours had him make love to her "goddess," a central figure of her art. John Boyle introduced Thomson's figure into his portraits of Canadian heroes, mythical figures, and Boyle himself.

For Gordon Rayner and Michael Snow, the legend had an unconscious vision of its own, and was open to a wide interpretation as in Rayner's freewheeling subversion of the canvas, particularly in his Magnetawan paintings, or in Snow's reconstruction of the world in his Ektacolour prints. Despite his idealistic statements about Thomson's work, Rayner's large *Drowning* canvases show objects that might have been washed up on shore after Thomson's death: a ruler, an old shirt, and even an old black felt hat. "I've always wanted to do a series of peculiarly Canadian paintings," says Rayner. Thomson's story provides the armature of myth. Snow, in *Plus Tard* (1977), used photographs of *The Jack Pine*, among other works by

Thomson, to indicate how we might see them displayed at the National Gallery of Canada. His was a film camera view: the paintings were blurred and out-of-focus. The photographs he took included the labels, the walls, and doorway of the gallery, an apt metaphor for the way we recall works of art: in their settings.

The use of a Thomson motif adds a familiar quality to contemporary work, and artists who use it think of themselves as part of the family of Canadian art. The way it is used is diverse. It can be seen in the work of Rodney Graham, who in his *Camera Obscura*, a 1979 multi-media work, included a Cibachrome print of an inverted tree, combined with a cardboard and balsa-wood model (showing the way the photograph had been made using an early form of camera) to indicate the precarious condition of the environment. The same motif can also be seen in Brian Burnett's 1995 show, *Iconograph-a-Tree*, at Gallery One in Toronto. Burnett worked a tree into every painting's title and subject.

Today, Thomson provides an example of a politically and environmentally innocent countryman for the 1990s. As the news about our environment grows more dire, artists — and we, the public — respond with growing eagerness to Thomson's work and to those who replay that imagery or myth. This reaction is not only a form of escapism to a recollection of a simpler, better time, but has become, it seems, an essential part of being Canadian. To

101

meditate on Thomson or his memory refracted through the work of his host of followers is a way of tapping into Canadian culture before we face the burden of the international present. He represents for us a powerful image of a "natural" painter, one we study in relationship to an imagined political and economic community that is fundamentally urban. He symbolizes our longings, not our realities.

The association of Thomson with Canadian culture will always be in flux. His work, and even his life, are less repositories of fixed and final meaning for us to decipher than they are charges of psychic energy to be rediscovered by every generation according to its own needs and will. The myth of Tom Thomson, in this sense, has its own validity, and is not unlike the powerful myths of other nations.

There is something about Thomson's work that the public sees as inherently Canadian, and his paintings have been popularized through stamps, place mats, T-shirts, silk scarves, and pins. In a recent book that I wrote on masterpieces by Thomson and the Group of Seven, *Northern Lights*, I suggested for the cover a powerful, brilliantly coloured, though little-known decorative landscape by Lawren Harris. Booksellers turned it down as "not Canadian enough"; the publisher substituted a canvas by Thomson. Unquestionably, his work, and the legend of his life, have become a central part of our image of the country. What we really see when we look at his

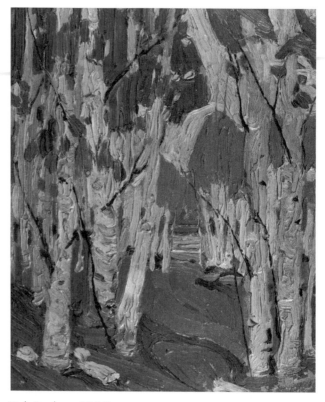

Pink Birches, 1915
Oil on board, 26.7 x 21.6 cm
Private collection, Toronto.
Photograph courtesy of Joan Murray Tom Thomson Papers.

paintings is not so much the image itself as the homage we pay as visitors, as followers of reports from Sotheby's, or even as schoolchildren. Artists who reach for his work today use it as a touchstone. It simultaneously lends credence to their own work, and serves as a springboard to their own vision of Canadian art, much in the way Thomson himself used other artists as his springboards. It's the perfect tribute: a re-creation of spirit. Perhaps in the future they will pay more attention to Thomson's mystic insight — his ability to see "into the life of things" (as Wordsworth described it). We must realize that he is a Canadian hero for all time. We will have to put up with him looking over our shoulders to give us a few pointers whenever we decide to design our culture anew.

Axe Handle, c. 1916
Wood
Robert and Signe McMichael.

Selected Bibliography

Primary Sources

Blodwen Davies Papers (MG 30 D24), National Archives of Canada, Ottawa.

Lawren Harris Papers (MG 30 D208), National Archives of Canada, Ottawa.

Dr. James M. MacCallum Papers, National Gallery of Canada, Ottawa.

Joan Murray, Tom Thomson, Catalogue Raisonné. Various interviews, letters, photographs, and lists, also William Graham Papers.

Tom Thomson Collection (MG 30 D284), National Archives of Canada, Ottawa.

Various letters, the McMichael Canadian Art Collection, Kleinburg.

Interview with Daphne Crombie, Algonquin Park Museum, Whitney, Ontario.

Useful Articles and Books

Addison, Ottelyn. *Early Days in Algonquin Park.* Toronto: McGraw-Hill, Ryerson, 1974.

— and Elizabeth Harwood. *Tom Thomson, Algonquin Years.* Vancouver, Winnipeg and Toronto: Ryerson Press, 1969.

Berger, Carl. *Science, God, and Nature in Victorian Canada.* Toronto: University of Toronto Press, 1982.

Bermingham, Ann. *Landscape and Ideology.* Berkeley: University of California Press, 1986

Bordo, Jonathan. "Jack Pine — Wilderness sublime or erasure of the aboriginal presence from the landscape." *Journal of Canadian Studies* 27, No. 4 (Winter 1992-93), pp. 98-127.

Brown, F. Maud. *Breaking Barriers.* Toronto: Society for Art Publications, 1964.

Clark, Robert Judson (ed.) *The Arts and Crafts Movement in America 1876-1916* (exhibition catalogue). Princeton: Art Museum and The Art Institute of Chicago, 1972.

Colgate, William. *Two Letters of Tom Thomson, 1915 & 1916.* Weston, Ont.: Old Rectory Press, 1946.

Daniels, Stephen. *Fields of Vision.* Oxford: Polity Press, 1993.

Davies, Blodwen. *A Study of Tom Thomson: The Story of a Man Who Looked for Beauty and for Truth in the Wilderness.* Toronto: Discus Press, 1935.

—. *Tom Thomson. The Story of a Man Who Looked for Beauty and for Truth in the Wilderness.* Reprinted. Vancouver: Mitchell Press, 1967.

Frayne, Trent. "The Rebel Painter of the Pine Woods." *Maclean's Magazine,* July 1953, pp. 16-17, 30-33.

Freemantle, Anne (selected and ed.). *The Protestant Mystics*. Boston and Toronto: Little, Brown and Company, 1964.

The Fundamentals of the Printing and Duplicating Processes. n.p.: Howard Smith Paper Mills, 1949.

Galbraith, John Kenneth. *The Scotch*. Toronto: Macmillan, 1964.

Gauslin, Lillian M. *From Paths to Planes: A Story of the Claremont Area*. Claremont, Ont.: By the Author, 1974.

Glazebrook, George P. de T. *The Story of Toronto*. Toronto: University of Toronto Press, 1971.

Gwyn, Sandra. *Tapestry of War*. Toronto: HarperCollins, 1992.

Housser, F.B. *A Canadian Art Movement*. Toronto: Macmillan, 1926.

Hubbard, R.H. *Tom Thomson*. The Gallery of Canadian Art, no. 2. Toronto: Society for Art Publications/McClelland and Stewart, 1962.

Jackson, A.Y. *A Painter's Country*. Toronto: Clarke, Irwin, 1958.

Killan, Gerald. *Protected Places: A History of Ontario's Provincial Parks System*. Toronto: Dundurn, 1993.

Killinger, Barbara. *Workaholics: The Respectable Addicts*. Toronto: Key Porter Books, 1991.

Lismer, Arthur. "Tom Thomson 1877-1917, a Tribute to a Canadian Painter." *Canadian Art 5* (December 1947), pp. 59-62.

—. "Tom Thomson (1877-1917) Canadian Painter." *Educational Record of the Province of Quebec 80* (July-September 1954), pp. 170-75.

Little, William T. *The Tom Thomson Mystery*. Toronto: McGraw-Hill, 1970.

MacCallum, J.M. "Tom Thomson: Painter of the North." *Canadian Magazine 50* (March 1918), pp. 375-85.

MacGregor, Roy. "The Legend: New Revelations on Tom Thomson's Art — and on his Mysterious Death." *Toronto Star, The Canadian*, October 15, 1977.

—. *Shorelines, a Novel*. Toronto: McClelland and Stewart, 1980.

McLeish, John A.B. *September Gale*. Toronto and Vancouver: J.M. Dent & Sons, 1955.

Mitchum, Allison. *The Northern Imagination: A Study of Northern Canadian Literature*. Moonbeam, Ont.: Penumbra Press, 1983.

Murray, Joan. *The Art of Tom Thomson* (exhibition catalogue). Toronto: Art Gallery of Ontario, 1971.

—. "The Artist's View: The Tom Thomson Mystique." *Artmagazine*, no. 37 (1978), pp.2-5.

—. *The Best of the Group of Seven*. Edmonton: Hurtig Publishers, 1984; repr. Toronto: McClelland and Stewart, 1993.

—. *The Best of Tom Thomson*. Edmonton: Hurtig Publishers, 1986.

—. "The World of Tom Thomson." *Journal of Canadian Studies*, 26 (Fall 1991), pp. 5-51.

—. *Northern Lights: Masterpieces of Tom Thomson and the Group of Seven*. Toronto: Key Porter, 1994.

—. *Tom Thomson: The Last Spring.* Toronto: Dundurn Press, 1994.

—. *Confessions of a Curator.* Toronto: Dundurn Press, 1996.

Newell, Gordon and Don Sherwood. *Totem Tales of Old Seattle: Legends and Anecdotes.* New York: Ballantine Books, 1956.

Northway, Mary L. *Nominigan, a Casual History.* Toronto: Brora Centre, 1969.

Owen Sound Collegiate and Vocational Institute, 125th Anniversary Auditorium. Owen Sound: Stan Brown, 1980.

Quinney, Bill, "Tom Thomson: A Naturalist Painter," unpublished paper for the Master's Degree, University of Toronto (JM, TTP.)

Reid, Dennis. *The MacCallum Bequest* (exhibition catalogue). Ottawa: National Gallery of Canada, 1969.

—. *Photographs by Tom Thomson.* Bulletin no.16. Ottawa: National Gallery of Canada, 1970.

—. *Tom Thomson, The Jack Pine.* Masterpieces in the National Gallery of Canada, no. 5. Ottawa: National Gallery of Canada, 1975.

Ring, Dan. *David Alexander: Continental Drift* (exhibition catalogue). Saskatoon: Mendel Art Gallery, 1995.

Robson, A.H. *Canadian Landscape Painters.* Toronto: Ryerson Press, 1932.

—. *Tom Thomson.* Toronto: Ryerson Press, 1937.

The Royal Society of Canada. *Fifty Years Retrospect: Canada, 1882-1932.* Toronto: The Ryerson Press, 1932.

Seton, Ernest Thompson. *Trail of an Artist-Naturalist.* New York: Charles Scribner's Sons, 1940.

Shikes, Ralph E. and Paula Harper. *Pissarro: His Life and Work.* New York: Horizon Press, 1980.

Stacey, Robert. *"Tom Thomson: Deeper into the Forest," OKanada* (catalogue). Berlin: Akademie der Künste, 1982-1983.

Sowby, Joyce K. "Quality Printing. A History of Rous and Mann Limited, 1909-1954." N.p., 1969.

Toronto. Art Gallery of Ontario. *100 Years: Evolution of the Ontario College of Art* (exhibition catalogue). Toronto: Art Gallery of Ontario, 1977.

Town, Harold and David P. Silcox. *Tom Thomson: The Silence and the Storm.* 2nd ed. Toronto: McClelland and Stewart, 1982.

Ufland, Vina R. *History of Sydenham Township.* Owen Sound, Ont.: n.p., 1967.

Vercingétorix et Alésia (exhibition catalogue) Saint-German-en-Laye: Musée des Antiquités nationales, 1994

Weisberg, Gabriel P. *Beyond Impressionism: The Naturalist Impulse.* New York, Harry N. Abrams, 1992.

Welsh, Jonathan. *Letter To The West Wind.* Moonbeam, Ont.: Penumbra Press, 1980.

Wistow, David. *Tom Thomson and the Group of Seven.* Toronto: Art Gallery of Ontario, 1982.

Yearbook of Canadian Art 1913. London and Toronto: J.M. Dent & Sons, 1913.

Index